IMAGES
of America

COLUMBUS
1910–1970

On the cover: The northeast corner of Broad and High Streets is seen here in the late 1920s, a time when Columbus had a busy downtown district. (Author's collection.)

IMAGES
of America

COLUMBUS
1910–1970

Richard E. Barrett

ARCADIA
PUBLISHING

Copyright © 2006 Richard E. Barrett
ISBN 978-0-7385-4057-3

Published by Arcadia Publishing
Charleston, South Carolina

Printed in the United States of America

Library of Congress Catalog Card Number: 2006921313

For all general information contact Arcadia Publishing at:
Telephone 843-853-2070
Fax 843-853-0044
E-mail sales@arcadiapublishing.com
For customer service and orders:
Toll-Free 1-888-313-2665

Visit us on the Internet at www.arcadiapublishing.com

CONTENTS

ACKNOWLEDGMENTS

The author would like to acknowledge the assistance provided by the people who permitted the author access to their photograph collections. Specific thanks are due the staff of the Biography, History and Travel Department of the Columbus Metropolitan Library and to local historians Bruce Warner and William Richardson.

Special thanks are due the author's wife, Margie, who has supported his interest in local history for over three decades.

INTRODUCTION

Volume I in this work, Images of America: Columbus: 1860–1910, covered a period of considerable growth in Columbus. The present volume shows scenes and activities during the next six decades of Columbus's existence.

In 1910, when this volume begins, Columbus was an industrial, manufacturing, business, government, and education center. Over the period of time covered here, Columbus lost much of its industrial and manufacturing enterprises and transformed into a government, education, research, and financial (banking and insurance) center. Through all of the period covered by this book, the downtown area of Columbus was the center of much activity—working, shopping, the arts, fine dining, and so on. Thus, transportation to the city center was vital to most activities. As this volume ends, Columbus was in the beginning of a transformation that saw rapid growth of the suburbs and the dissipation of activities to outlying areas.

The material presented in Images of America: Columbus: 1910–1970 is divided into sections representing each of six decades of local history. A special chapter is devoted to the 1913 flood in Columbus, an event that claimed about 100 lives and resulted in flood avoidance steps that forever changed the face of downtown Columbus. In addition, two chapters are devoted to institutions that were important to Columbus both before and during the period of interest, specifically the Ohio Penitentiary and Ohio State University.

As there was limited use of cameras before the Civil War, some of the earliest views of the penitentiary are represented by drawings. Later views are more often represented by photographs. It is unfortunate that some original photographs do not appear to have been preserved and, thus, the views presented have had to be extracted from materials that were published many years ago.

Much of the material presented in this book is from the author's personal archive, collected over a 34-year period. Other views were obtained from the Columbus Metropolitan Library's Biography, History and Travel Department, which has assembled a collection of over 8,500 views of the Columbus area. Fellow historians Bruce Warner and William Richardson assisted by offering their personal collections of views for the author's use.

The author is a well-known local historian having authored six previous books, authored and narrated 12 one-half hour television presentations, and currently authors a column, Postcard from Columbus, that was once carried in the Columbus Dispatch Sunday Magazine and now appears in the Senior Times. In addition, he regularly speaks on a variety of Columbus-area history topics. He is an active member of the Columbus and Clintonville Historic Societies and the African-American Community Advisory Board on Columbus's black history. In 2004, he received the Columbus Historical Society's first "Heroes of History Award."

One

1910–1919

A Strike, Celebrations, and Camp Willis

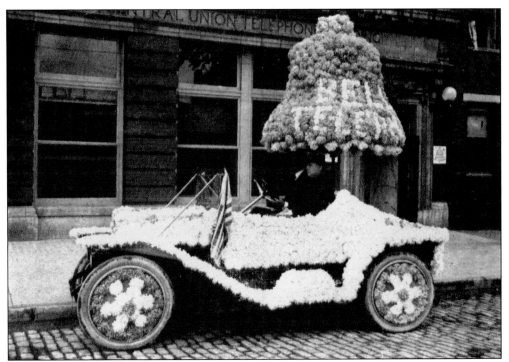

In the summer of 1910, Columbus held its first Industrial Exposition featuring "Made in Columbus" products. The purpose was to inform businesspersons and consumers of the many locally manufactured products. The Bell Telephone Company decorated an automobile with flowers to serve as a float in the exposition parade.

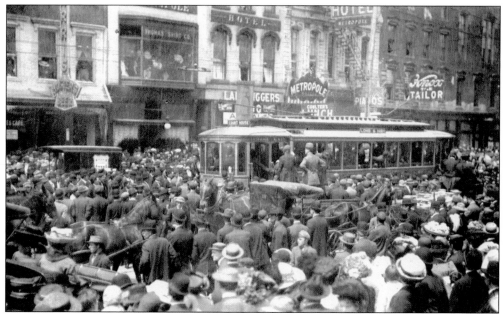

Columbus suffered its most violent labor dispute in the summer of 1910. Streetcar motormen struck for higher wages, shorter hours, and recognition of their union. This photograph shows a crowded High Street scene on the first day of the strike, April 29, as striking motormen attempt to keep the streetcars from operating.

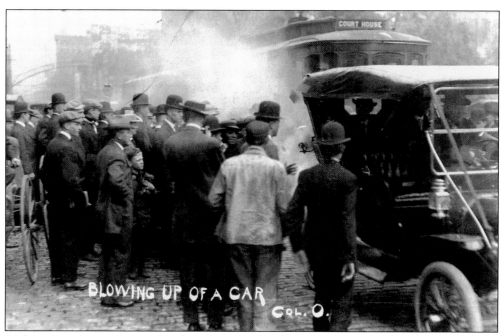

Striking motormen attempted to knock streetcars off the tracks or to otherwise damage the streetcars. The caption on this photograph says, "Blowing up of a car." However, it is doubtful such a large crowd would be gathered so close if the streetcar was being dynamited.

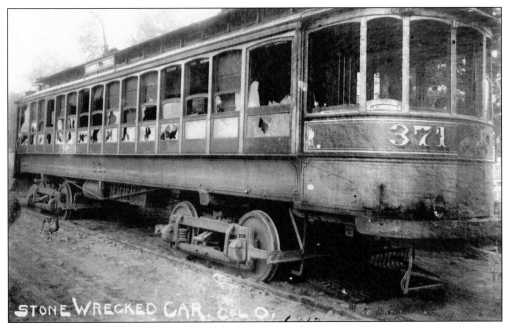

This streetcar has suffered damage by rock-throwing strikers.

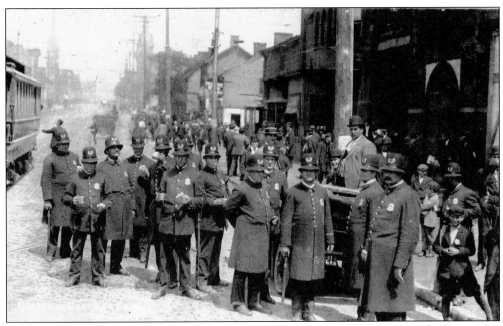

Policemen were utilized in an attempt to control the damage to the streetcar facilities. This photograph shows police gathered at the streetcar barn at 550 South High Street. Ohio National Guard troops were also called out. By early May, the strikers and the Columbus Railway and Light Company had reached an agreement and strike activity had terminated.

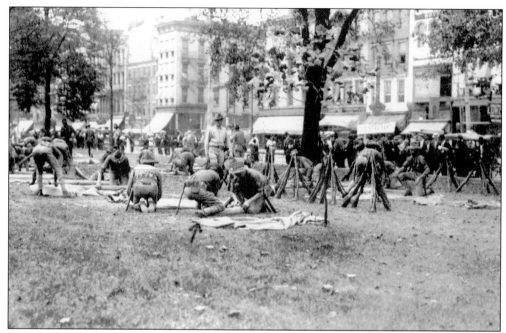

Continuing differences between the union and the railway company resulted in another strike beginning on July 24, 1910. Three days later, the National Guard troops were called out again. This photograph shows troops encamped on the statehouse grounds. The State Street and High Street intersection is in the background.

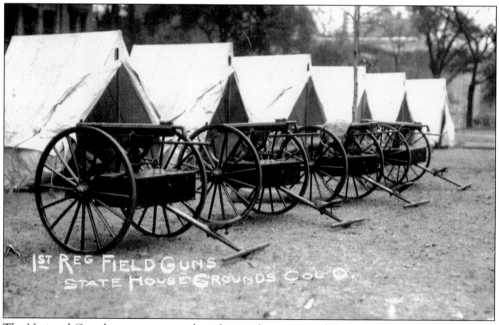

The National Guard troops encamped on the statehouse grounds brought armament with them.

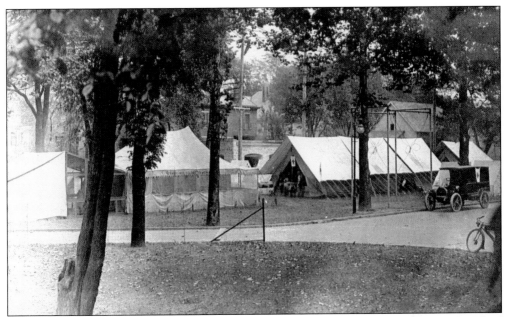

This photograph shows a troop encampment on the grounds of the Ohio School for the Blind at Main Street and Parsons Avenue.

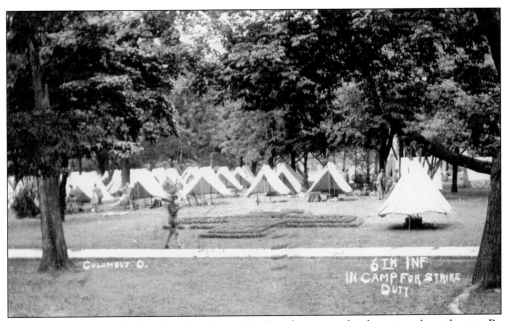

Troops were encamped at Schiller Park (shown here) and various other locations about the city. By fall, most of the strikers had returned to work although the railway company had not succumbed to their demands. Over time, however, the company implemented some of their requests.

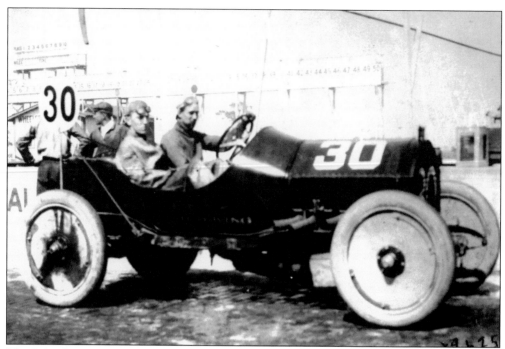

The Columbus Buggy Company built a special race car, the Red Wing, which they entered in the first Indianapolis 500-mile race in 1911. Although the car did not complete the race, the car's designer, Lee Frayer, and riding mechanic Eddie Rickenbacker were credited with a 13th-place finish.

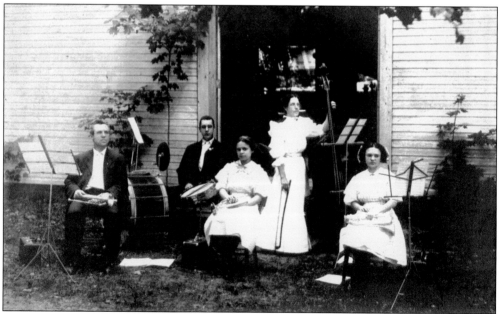

The Eby family of 155 East Fifth Avenue in Columbus, Ohio, described itself as a "musical combination" in 1910. None of the four Eby families reported in Columbus in the 1910 census has musician listed as their occupation and none had family members matching those in the picture, so they remain a mystery.

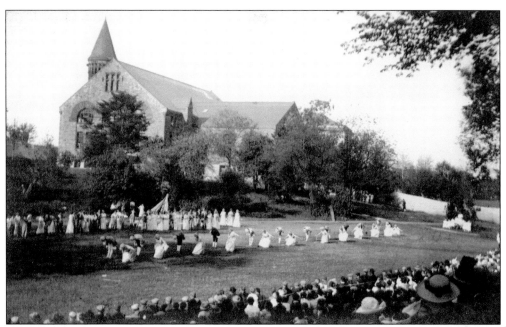

On May 12, 1912, *The Birth of Ohio*, a reenactment of the settling of Ohio, was preformed in Columbus by Ohio State University students. This photograph shows that the reenactment was located on the grassy area south of Orton Hall on the Ohio State University campus.

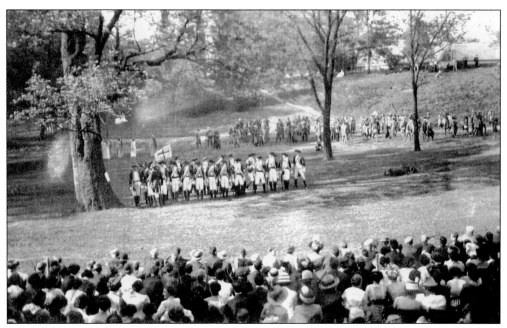

From these and other photographs, it is obvious that dozens of students participated in the reenactment, all in costume. The amazing thing is that, with all the preparation necessary to execute the reenactment, it was only performed once.

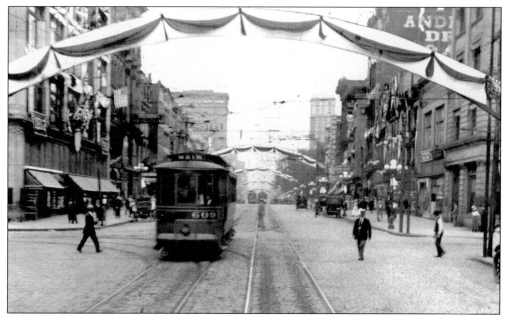

From August 26 to September 6, 1912, Columbus celebrated its centennial. This photograph shows a streetcar at Town and High Streets passing beneath the arches that were decorated for the centennial. The arches were installed in 1896 and survived until 1914.

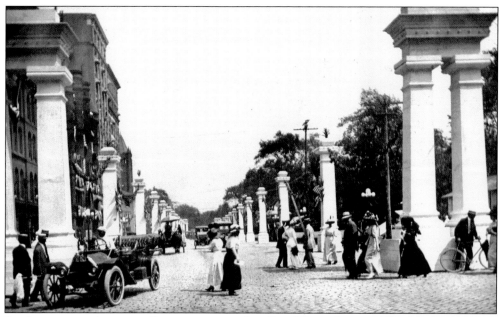

For the centennial, a court of honor was erected on Broad Street between Third Street and High Street. Looking east from High Street, the statehouse grounds are on the right.

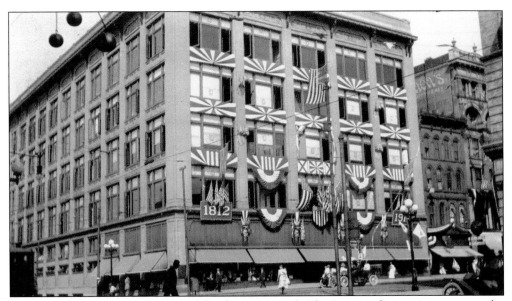

Columbus buildings were decorated for the centennial. The Lazarus department store on the northwest corner of Town and High Streets is shown here. The dates of Columbus's founding (1812) and the centennial (1912) were displayed on the front of the store.

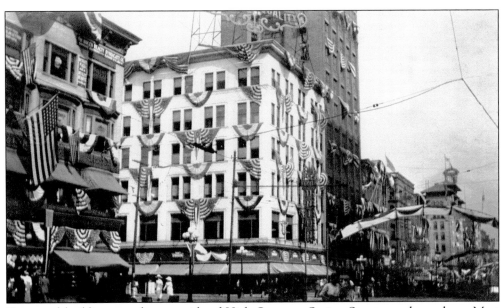

Decorated buildings on the west side of High Street at Spring Street are shown here. Most prominent is the Union store, the white building in the center of the photograph. The Chittenden Hotel is visible near the right edge of the picture.

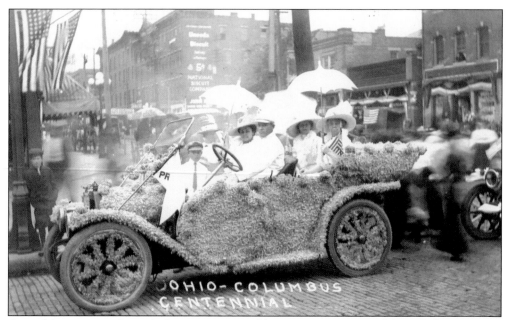

One of the centennial parade floats was prepared by covering an automobile with flowers.

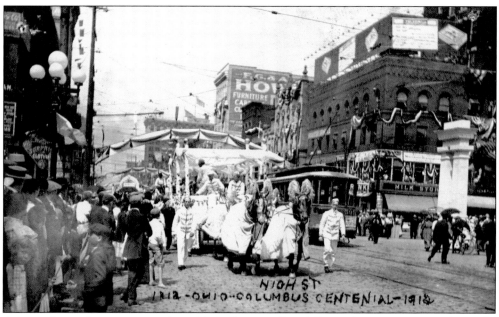

A horse-drawn float moves south on High Street at Broad Street during a centennial parade. The court of honor is visible at the right.

In 1912, a station was built on the northwest corner of Rich and Third Streets for all but one of the interurban lines serving Columbus. This eliminated the need for passengers arriving on one line to walk to another station if they were to depart on a different line. Also, the boarding area for the interurban cars was off the street, eliminating congestion. One interurban company, the Scioto Valley Traction Company, continued to maintain their own station on the northeast corner of the same intersection.

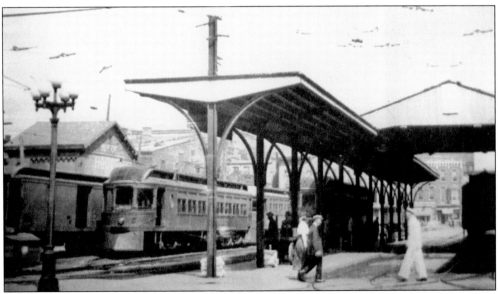

This photograph shows the boarding area of the new interurban station with several interurban cars in place to discharge and receive passengers. The interurban station was used until interurban service to Columbus ceased in 1938. It later became an A&P grocery store.

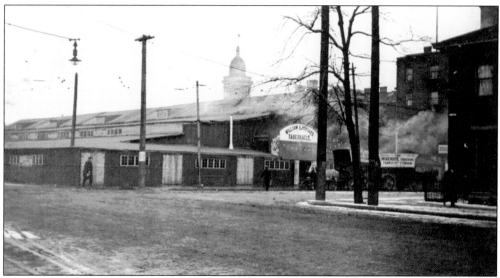

Billy Sunday came to Columbus for a crusade that ran from December 1912 to February 1913. A tabernacle was erected on the northeast corner of Goodale and Park Streets for the crusade meetings. The wooden tabernacle, intended to be a temporary structure, was erected in four days.

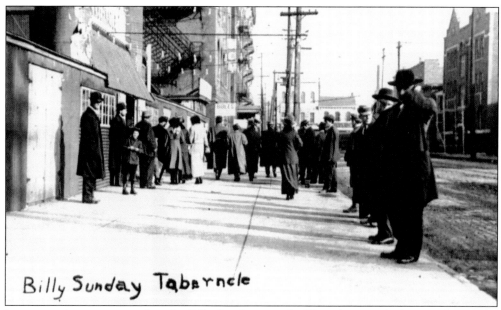

Billy Sunday Tabarncle

Large crowds were attracted to the Billy Sunday crusade. This photograph shows only men, as separate meetings were held for men and for women.

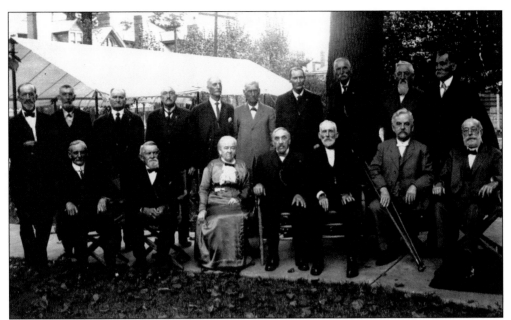

Veterans of the 11th Ohio Battery held a reunion at the home of Major Neil in Columbus in 1913. Neil is to the right of the man with crutches; the woman was Mrs. Neil. Two attendees were not present when the photograph was taken. The group lamented that attendance had dropped from 30 who were present at their last reunion (in 1898) to 18.

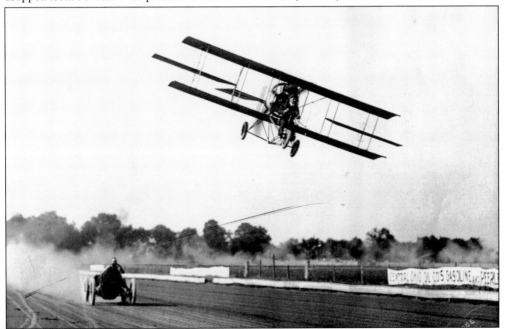

On June 6, 1914, a "race" between an automobile and an airplane was staged at the driving park in southeast Columbus. Such events were popular attractions during this time when both the automobile and the airplane were undergoing rapid evolution. Columbus hosted two famous names for this event: the automobile was driven by Barney Oldfield and the airplane by Lincoln Beachey.

The Majestic Theater opened on High Street opposite the statehouse in 1914. Erected before the introduction of "talkies," it is reported to have resisted the move to sound pictures, considering talkies just a fad. The Majestic operated until 1950, when the building was razed.

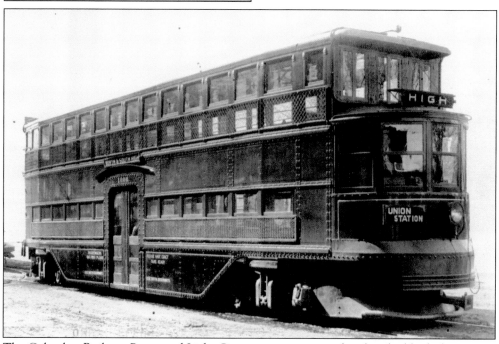

The Columbus Railway, Power and Light Company experimented with a double-deck streetcar in 1914. The experiment was short lived, as the streetcar was so large that it had difficulty negotiating turns. Thus, it was limited to service on the North and South High Street route.

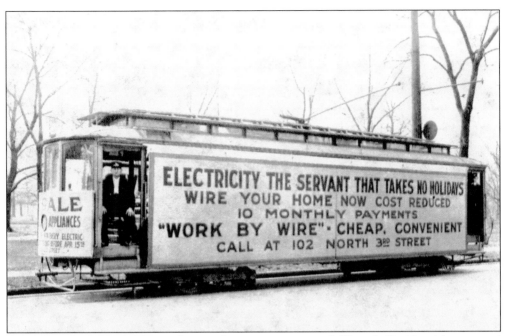

Another experiment in 1914 was the use of streetcars as moving billboards. Residential customers' greatest need for electricity would be at night when the streetcar load would be reduced. Thus, these customers offered a perfect market for the sale of off-peak power. This billboard advertises that a home could be wired for electricity with only 10 monthly payments and that electricity "takes no holidays."

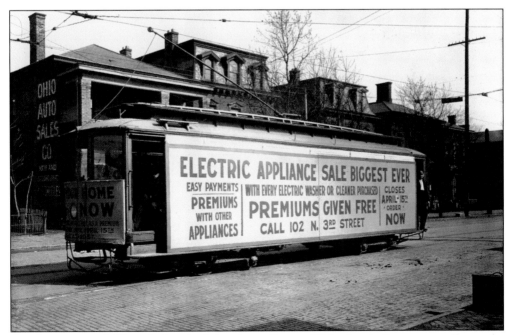

Another streetcar billboard advertised electric appliances. With electric lines strung all over the city to serve their streetcars, the company was equipped to serve the scattered residential market.

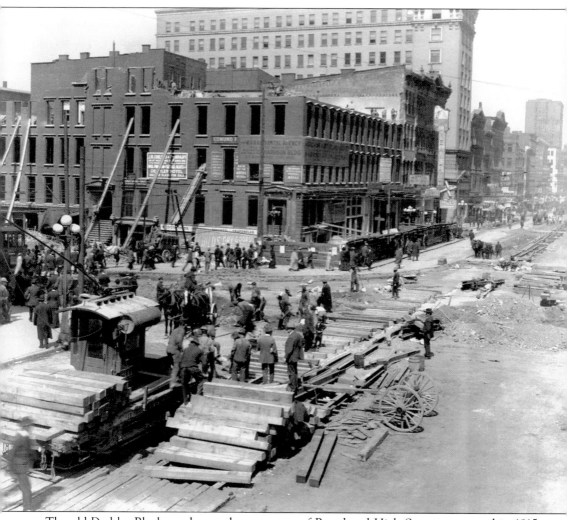

The old Deshler Block on the northwest corner of Board and High Streets was razed in 1915 to clear the way for the Deshler Hotel. Simultaneously, the streetcar tracks on Broad and High Streets were being upgraded.

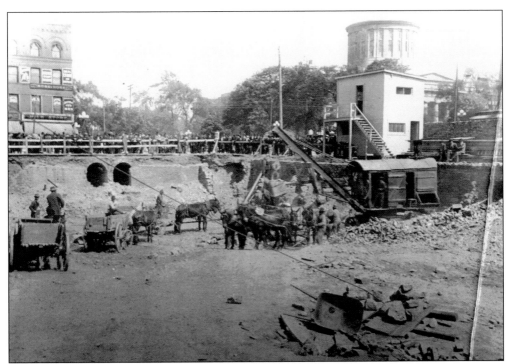

Once the Deshler Block was razed, work got underway to prepare a foundation for the new Deshler Hotel. A steam shovel and horse-drawn wagons were used to clear debris and dig the foundation. The statehouse rotunda is visible across the intersection.

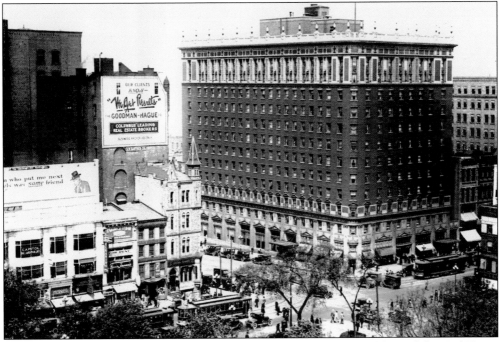

The 12-story Deshler Hotel was opened in 1916. For many years, the Deshler and the Neil House hotels were the preeminent hotels in Columbus. The Deshler Hotel was razed in 1969.

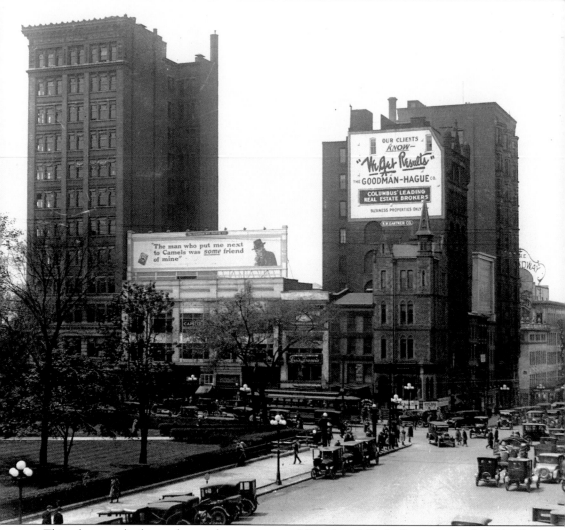

This photograph shows the southwest corner of Broad and High Streets around 1916. The tall building on the left is the Harrison Building. The castle-like building on the corner is the Huntington Bank, and the two tall buildings behind it are the Wheeler and Wyandotte buildings. In the days before traffic signals, driving must have required daring. The billboard proclaiming "The man who put me next to Camels was some friend of mine" would not be considered appropriate today.

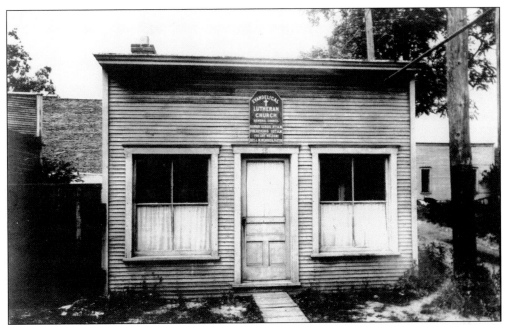

Hilltop Lutheran Church was organized in 1915 and first met in this building at 15 North Wayne Avenue. By 1919, it had moved into the new brick church on the southeast corner of Broad and Terrace Streets.

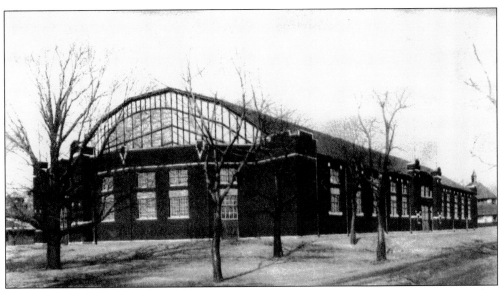

The coliseum on the Ohio State Fairgrounds was completed in 1916. Over the years, it has hosted a variety of events including animal shows at state fairs, circuses, basketball games, hockey games, and so on. For a number of years, the Ohio State University basketball team played its home games at the coliseum.

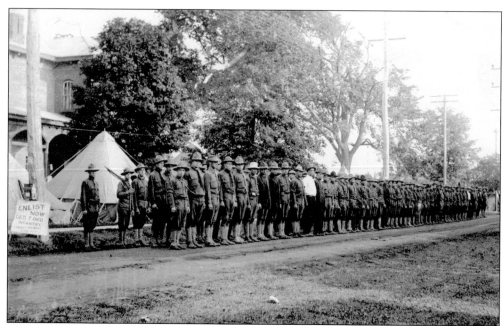

In 1916, Pancho Villa crossed the border from Mexico and raided the town of Columbus, New Mexico, killing Americans and destroying property. General Pershing led U.S. troops pursuing Villa and his outlaw band into Mexico. National Guard units in 44 states were called up to protect the U.S.-Mexican border while the U.S. Army was involved in pursuing Villa. Ohio's Guard units were assembled at Camp Willis on the outskirts of Columbus in what was the beginning of Upper Arlington. This photograph shows troops preparing to march to Camp Willis.

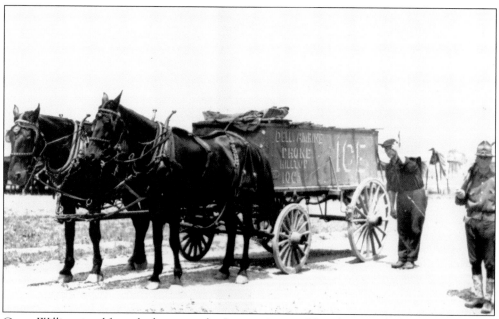

Camp Willis existed for only three months, June to August. This photograph shows a local dealer delivering ice to the camp. At its peak, some 8,000 troops were encamped at Camp Willis.

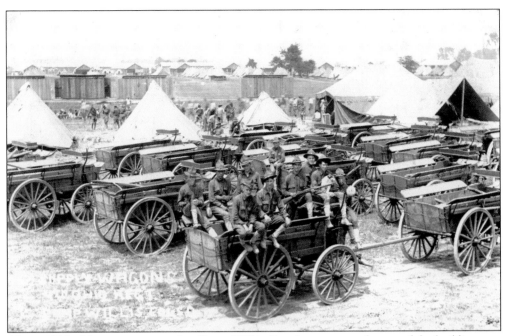

About 160 buildings were erected at Camp Willis. Supply wagons and some of the buildings are seen here. Camp Willis occupied most of the area between Fifth and Lane Avenues and between North Star Road and Route 33.

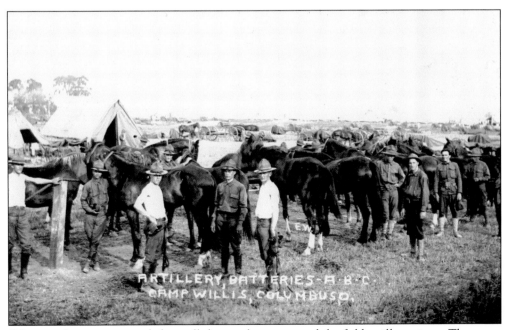

Of course, horses were needed to pull the supply wagons and the field artillery pieces. They were stationed in the northern part of the camp where there were shade trees.

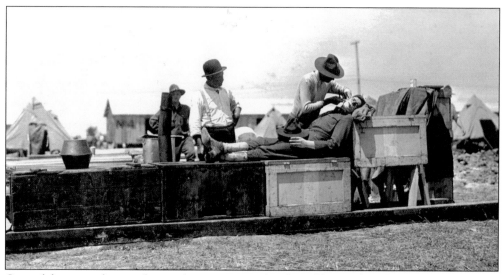

Camp life required more than military training for the soldiers. This photograph shows one soldier giving another soldier a shave. The makeshift barber chair was constructed of crates.

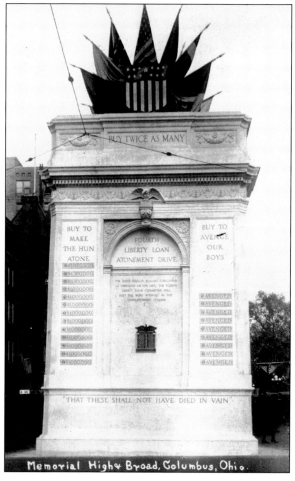

A memorial arch was erected in the middle of Broad Street just east of High Street in 1918. The arch served two purposes: to honor the memory of soldiers killed in World War I and to promote the sale of war bonds. It was dedicated on September 18, 1918, less than two months before the war ended.

Powell's Furniture store, 1160 North High Street, was advertised as a new and second-hand furniture store when this photograph was taken about 1913. The store was located between Fourth and Fifth Avenues, at the north end of what is now the Short North.

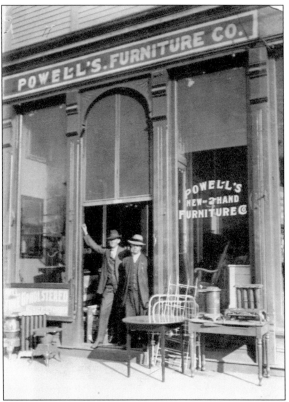

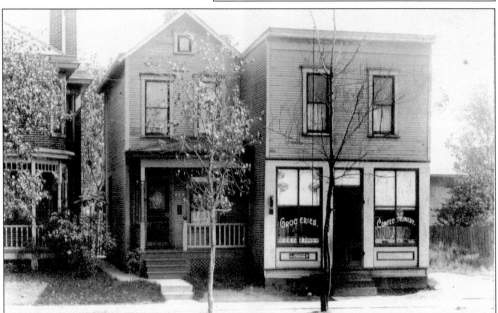

In the days before two-car families, the wives were usually left home during the day without a means of transportation. This meant they had to have access to shopping within walking distance. Neumerous small grocery stores were sprinkled around residential neighborhoods. This photograph shows one such store at 526 South Ohio Avenue in 1911.

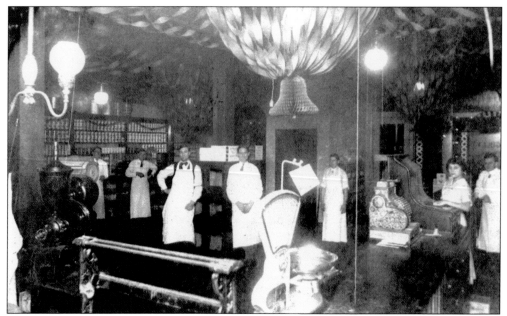

The staff of Fox and Scully, another neighborhood grocery store, posed for this photograph in 1912. The decorations hanging from the ceiling suggest that this photograph may have been taken at the store's opening. The store was located on Cleveland Avenue in Linden, a separate community. Linden was annexed to Columbus in 1920.

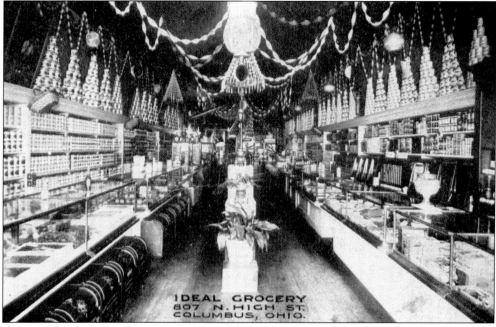

The neighborhood grocery stores were not self-serve like today's supermarkets. Instead, most of the merchandise was behind the counter and had to be requested. If a can of peas was needed, the customer asked the clerk for it. Although this store at 807 North High Street was obviously larger than the one on the previous page, the photograph illustrates the arrangement of merchandise at the neighborhood stores.

Two

1913

COLUMBUS'S WORST FLOOD

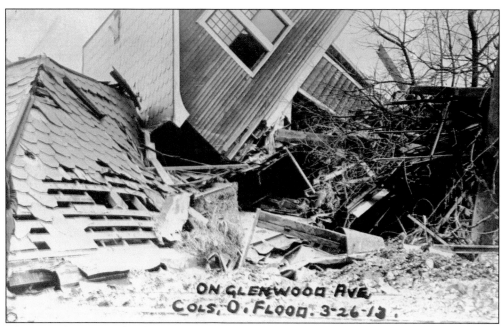

The most destructive flood ever to hit Columbus occurred in 1913. Ten inches of rain in three days in the Marion, Ohio, area caused both the Scioto and Olentangy Rivers to overflow. The impact of this flood on Columbus was far reaching. After the flood, the Scioto River was widened in downtown Columbus and development of the low-lying area west of the river, Franklinton, or "The Bottoms," lagged for almost a century.

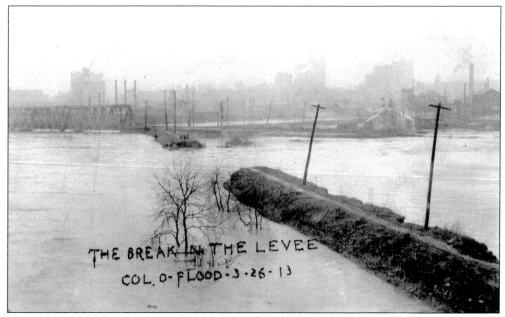

A break in the levee protecting Franklinton on March 25, 1913, permitted unlimited quantities of water to flow south through the community.

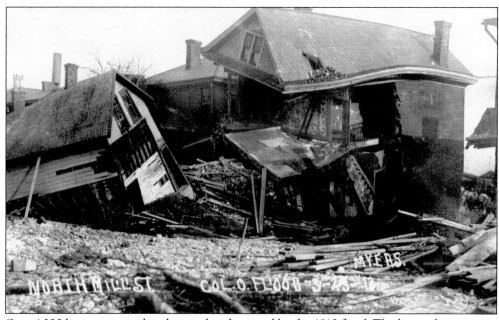

Over 4,000 houses were either damaged or destroyed by the 1913 flood. The listing for streets in Franklinton in a 1914 Columbus City Directory shows many addresses listed as "flood," signifying that the home was lost in the flood. This scene of destruction was on North Mill Street.

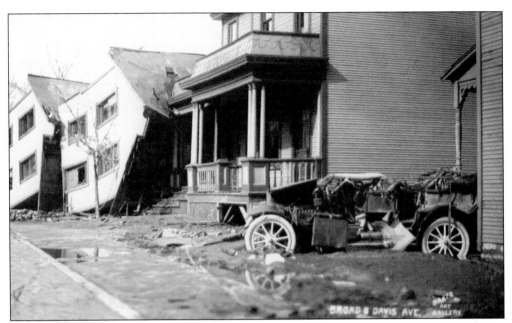

Two houses were simply tipped over on Davis Street near Broad Street, while an adjacent house remained upright. There were numerous reports of persons being rescued from the second stories of houses in the flood area. Between 90 and 100 lives were believed lost in Columbus as a result of the flood.

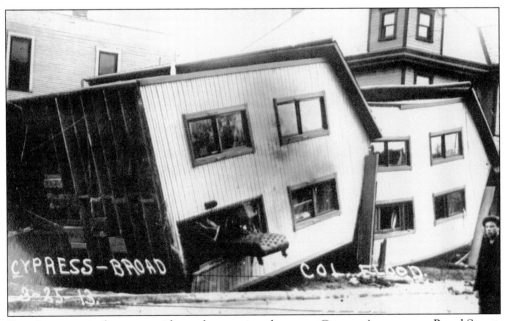

Seen here is a similar scene with two houses tipped over on Cypress Avenue near Broad Street. Obviously, most of the available photographs were taken after the water had subsided and, thus, do not show the water level at its peak.

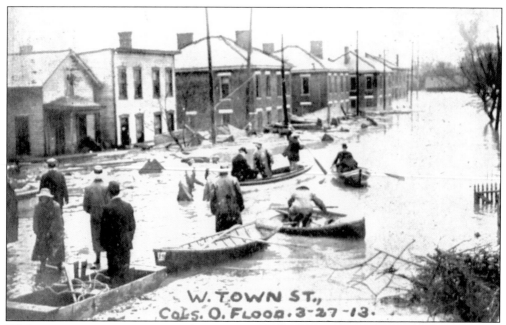

Of first importance was rescuing the survivors. Robert F. Wolfe of the Columbus Dispatch chartered interurban cars to go to Buckeye Lake, some 30 miles east of Columbus, to bring back boats and boatmen. He then dispatched the boats for rescue work and became a local hero.

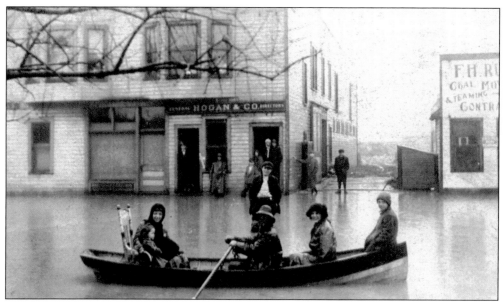

The rescue operation is in progress with three persons being retrieved from the flood zone.

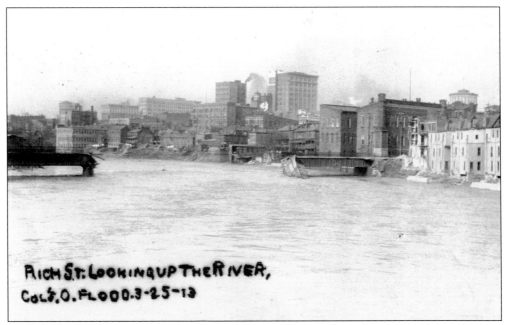

Three of the four bridges linking downtown Columbus (on high ground east of the Scioto River) to the low-lying Franklinton area were washed away by the flood. This photograph shows the destruction of the Town Street Bridge. Bridges at State Street and Broad Street were also washed away.

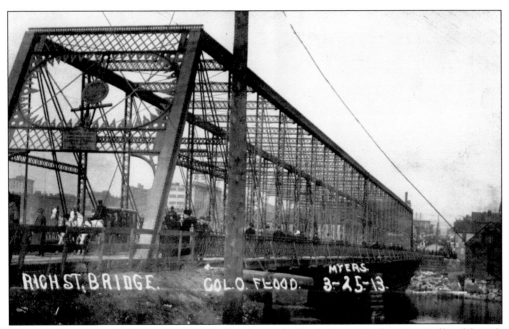

The one downtown bridge to survive the flood was the Rich Street Bridge. Ironically, although this bridge had been condemned after the 1898 flood, it provided a means for rescue and a way to provide aid to flood survivors.

With most transportation knocked out by the flood, any means were used to deliver aid to flood survivors. These men use a primitive method of delivering food.

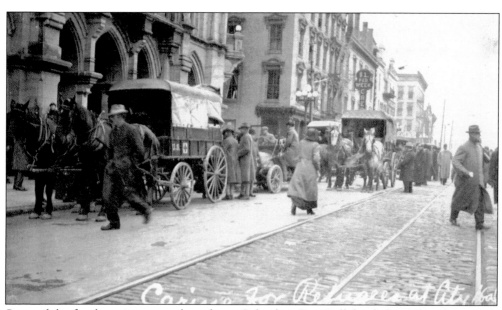

Some of the flood survivors were brought to Columbus City Hall for shelter. This photograph looks west on State Street. The city hall is the building to the left; it was located where the Ohio Theater is now located.

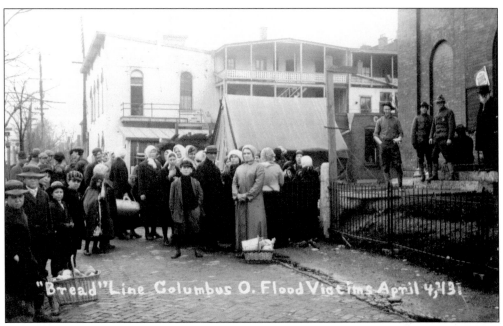

"Bread" Line Columbus O. Flood Victims April 4,'13.

There was a continuing need to aid flood survivors who may have lost their houses and all their possessions in the flood. This photograph shows the bread line about 10 days after the flood. National Guard troops are helping with the food distribution.

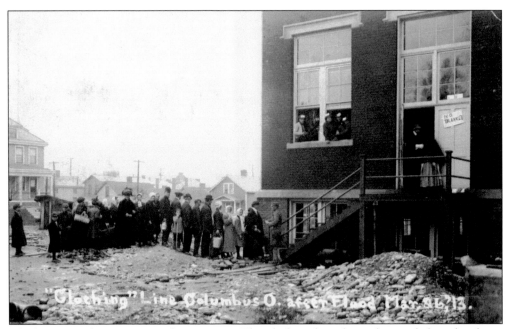

"Clothing" Line Columbus O. after Flood Mar. 26,'13.

Clothing was also a necessity for survivors. The clothing line shown here is believed to be at Holy Family School in the heart of the flooded area.

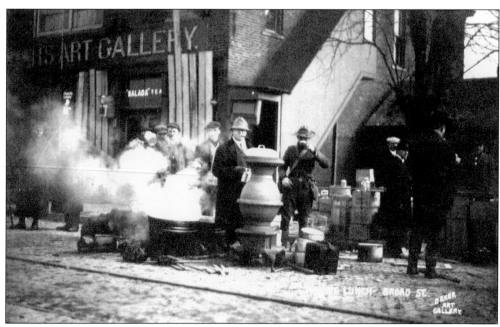

An improvised food station on West Broad Street provided nourishment for survivors and a National Guardsman during the flood recovery effort.

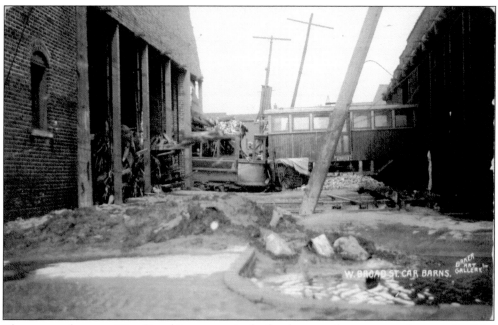

The streetcar barns on West Broad Street were in the flood area, and streetcars and support facilities suffered damage. It was one month before streetcar service could be restored in Franklinton.

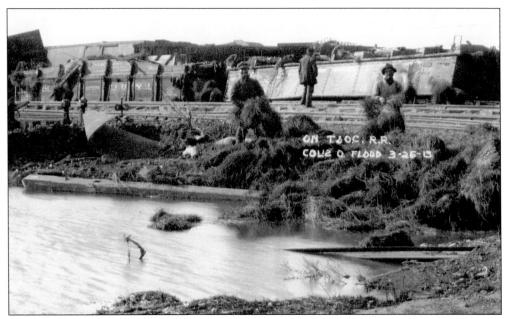

The flood was powerful enough to knock out railroad viaducts, wash away track bed, and knock engines and cars off remaining tracks. As Columbus was a major railroad hub, restoring railroad facilities was given a high priority in recovery efforts.

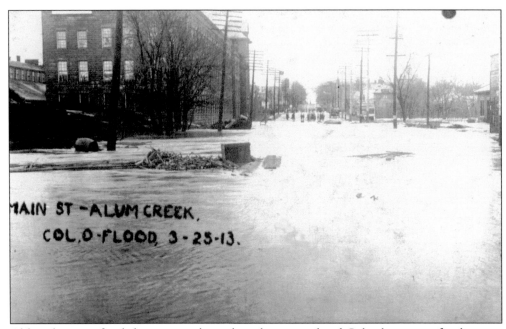

Although major flood damage was limited to the west side of Columbus, some flooding was experienced in other areas. This photograph shows flooding on East Main Street at Alum Creek.

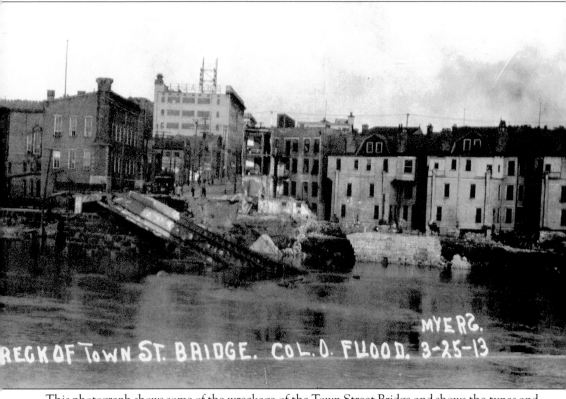

RECK OF TOWN ST. BRIDGE. COL. O. FLOOD. 3-25-13 MYERS.

This photograph shows some of the wreckage of the Town Street Bridge and shows the types and locations of buildings on the east bank of the river in downtown Columbus. Efforts to prevent future flooding included widening the river through downtown Columbus. Over the years, the area on the riverbank was razed, and the Civic Center was developed, with government buildings on the east bank and Central High School on the west bank.

Three

1920–1929

The Roaring Twenties

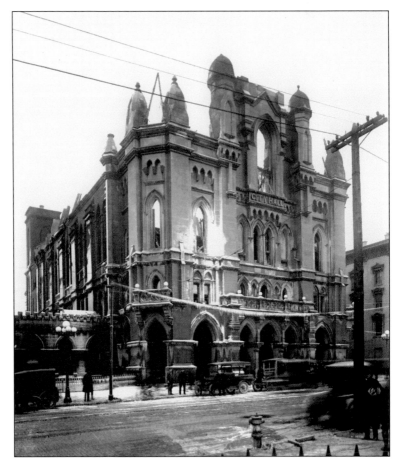

Columbus City Hall on East State Street burned in February 1921. Constructed in 1872, it was the first building in Columbus designed specifically to house city offices. In 1928, the Ohio Theater was constructed on the site.

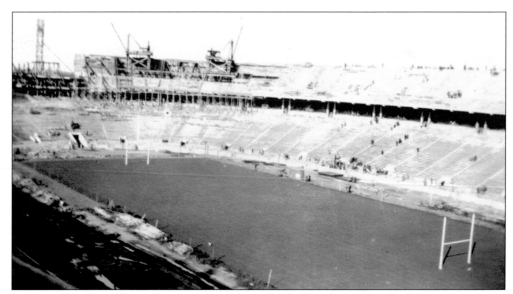

In 1922, Ohio State University was constructing a football stadium. Ohio Stadium was originally designed to seat 63,000 persons. Except for the dedication game in 1922, it was rarely filled until about 1950. It has now been renovated and has a capacity of 102,329 and is filled for nearly every game.

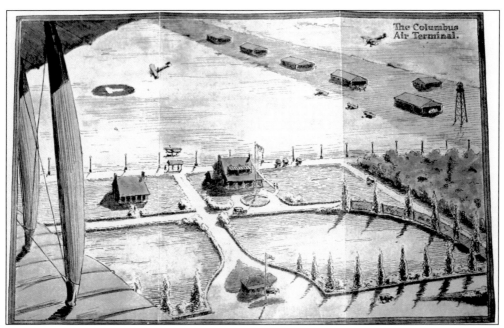

Columbus's first airfield was opened in 1923; it was named Norton Field after Fred Norton, an Ohio State University athlete killed in World War I. Located south of Broad Street and east of Yearling Road, it served as Columbus's major airport until Port Columbus was constructed in 1929. Norton Field operated into the 1950s, when the land was sold and developed for housing.

The existing Harrison Building had been purchased by the Huntington National Bank in 1915. In 1924, the existing building was incorporated into an enlarged building that began the new Huntington National Bank building.

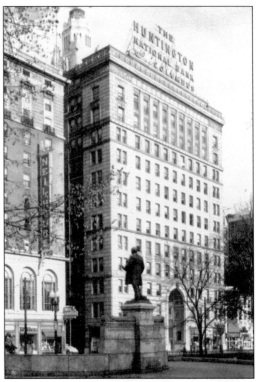

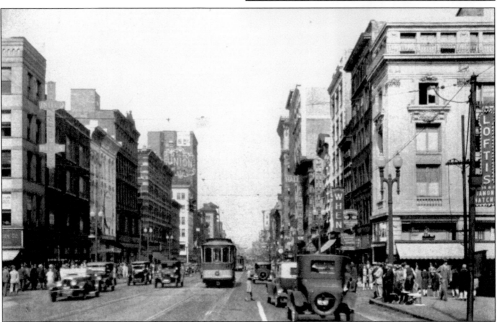

Looking north on High Street at Gay Street in the early 1920s, this photograph shows the difficulties faced by pedestrians in the days before traffic signals. A lady is attempting to cross High Street but is faced with avoiding automobiles. Also shown is a streetcar. The streetcars boarded and discharged passengers in the middle of the street, as they could not pull to the curb as buses can.

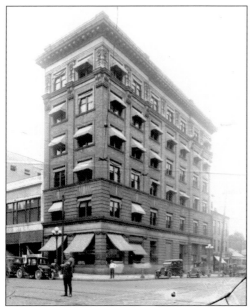

This view, looking northeast at High and Town Streets, shows traffic control before traffic signals were introduced in Columbus in 1924. A policeman stands at the center of the intersection to direct traffic. Other pictures show a policeman holding an umbrella with "Go" on two opposite panels and "Stop" on two other panels. By turning the umbrella one quarter of a turn the policemen could control traffic.

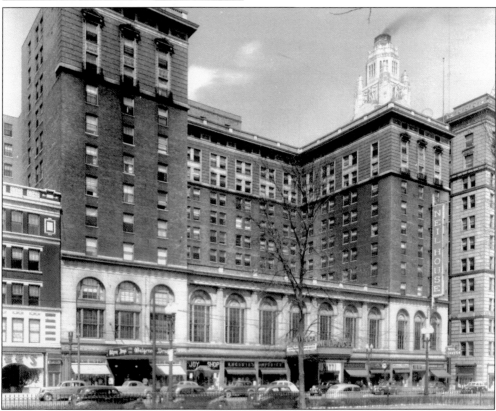

The Neil House hotel pictured here was the third Neil House to occupy the site on High Street opposite the statehouse. In 1924, the second Neil House was razed and this structure was erected. Until its razing in 1981, it was one of Columbus's premier hotels. The Huntington Center now occupies the former Neil House site.

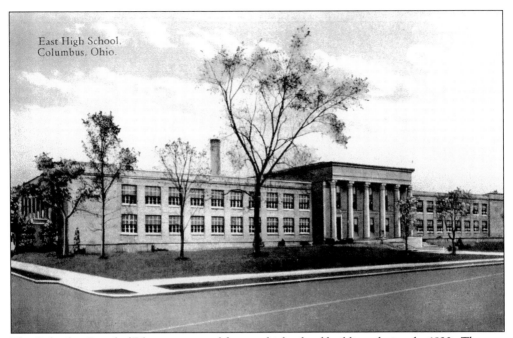

The Columbus Board of Education erected five new high school buildings during the 1920s. The new East High School was constructed in 1923 on East Broad Street just west of Franklin Park. It continues to serve as a high school. The old East High School became Franklin Junior High School.

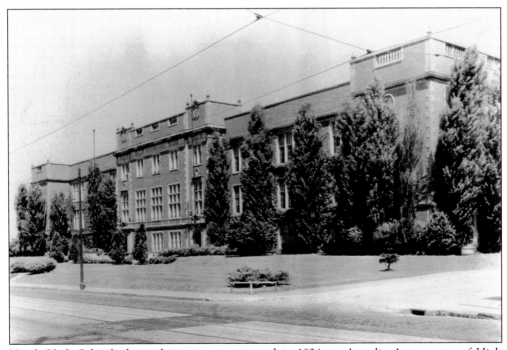

North High School, shown here, was constructed in 1924 on Arcadia Avenue east of High Street. The old North High School became Everett Junior High School. North High School closed in 1969, and the building currently houses the North Education Center High School.

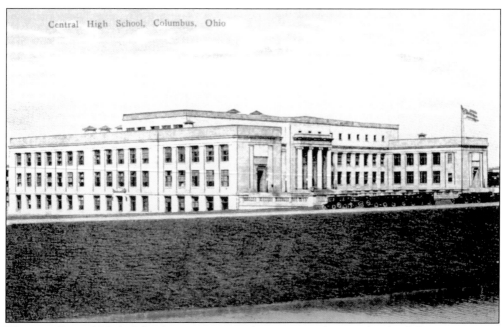

The new Central High School was constructed in 1924 on the west bank of the Scioto River just south of Broad Street. It was closed in 1982. In 1999, the Central High School building was extensively modified and enlarged and then was occupied by the Center of Science and Industry (COSI). The previous Central High School, at Broad and Sixth Streets, was razed after this school was erected.

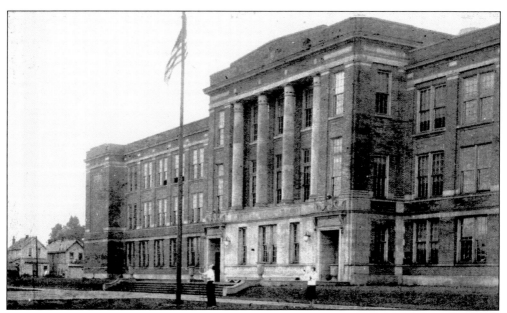

The new South High School was constructed in 1924 on Ann Street just north of Thurman Avenue. It continues to serve as a school but now operates as the South Urban Academy. The old South High School became Barrett Junior High School.

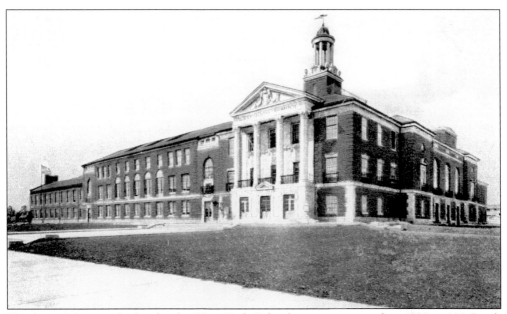

The last of the new high schools, West High School, was constructed in 1929 at 120 South Central Avenue. The old West High School became Starling Junior High School.

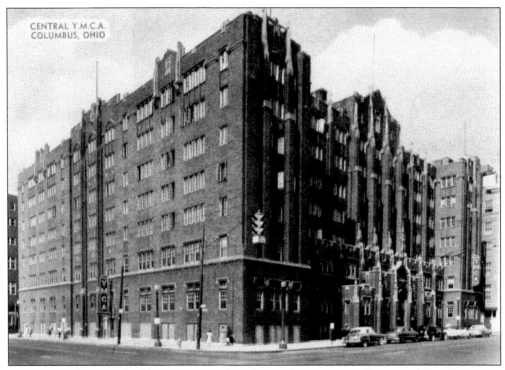

A new central YMCA building was opened on the northeast corner of Long and Front Streets in 1924. The building was recently renovated and is expected to serve for many more years.

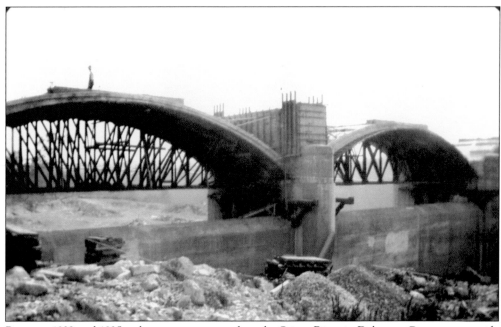

Between 1922 and 1925, a dam was constructed on the Scioto River in Delaware County to provide an additional water supply for Columbus. This photograph shows the dam during its construction.

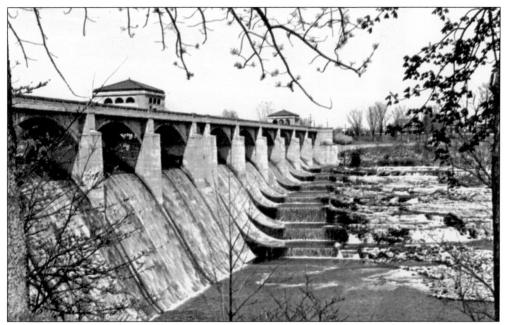

The new dam was named O'Shaughnessy Dam after water department superintendent Jeremiah O'Shaughnessy. Within a short period of time, Columbus began the development of a zoo on the east bank of the Scioto River just above the dam. Columbus's zoo has grown and acquired a national reputation.

Columbus erected a new city hall on the northwest corner of Broad and Front Streets in 1928. Originally constructed on three sides of a courtyard, the fourth side was added in 1934.

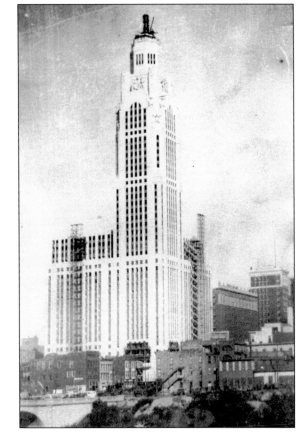

The American Insurance Union (AIU) Citadel was nearly finished in 1927 when this photograph was taken. At that time, it was the tallest building west of Manhattan and the fifth-tallest building in the world. At 555.5 feet, it is six inches taller than the Washington Monument and was Columbus's only building taller than 12 stories until 1962. Its current name is the LeVeque Tower.

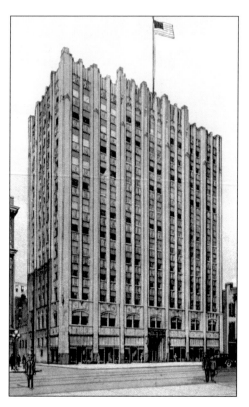

The Beggs Building was constructed on the south side of East State Street just east of High Street in 1928. An office building, it was enlarged in the 1990s and now is known as the Fifth Third Building.

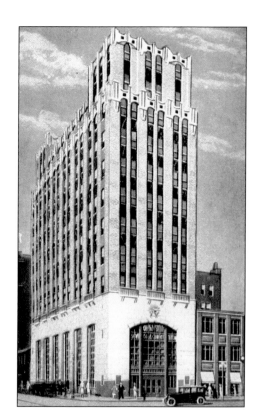

The Ohio State Savings and Loan erected this building on the southwest corner of Gay and Third Streets in 1927.

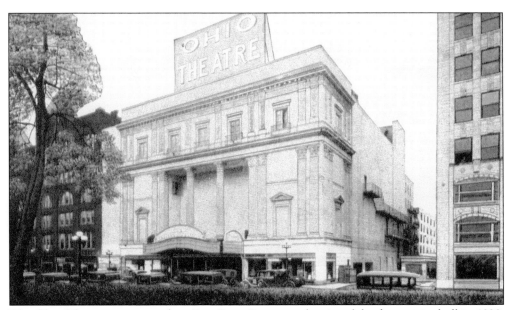

The Ohio Theater was erected on East State Street on the site of the former city hall in 1928. Although equipped with a Morton organ for accompanying silent movies, sound films were available when it was finished.

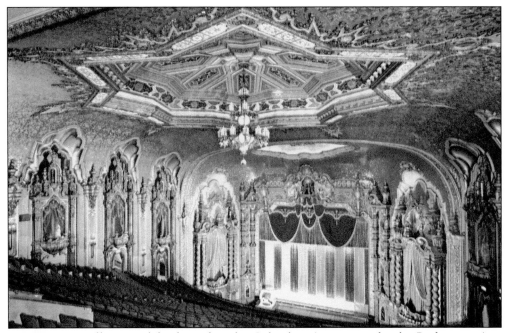

A community effort raised funds so that the Columbus Association for the Performing Arts could buy the Ohio Theater, which was almost razed in 1969. It has since been restored to its original beauty and is in frequent use.

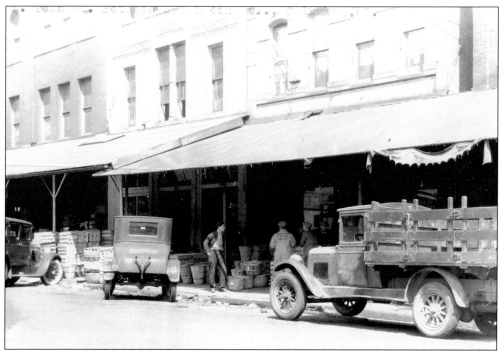

This view, looking east on Town Street between Third and Fourth Streets in 1928, shows a portion of the wholesale produce district that was located in this area, just north of the Central Market. Some of the persons selling produce at the stands near the Central Market would purchase their produce at these wholesale houses.

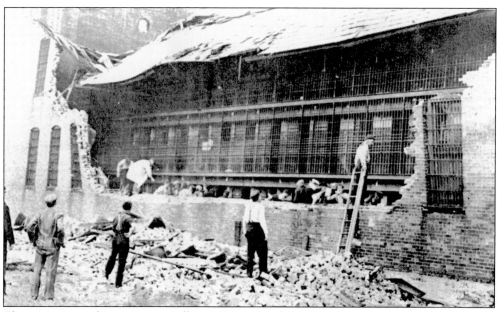

The temporary police station at Sullivant Avenue and McDowell Street was stuck by a tornado in 1929, killing two inmates. The previous police station on Town Street had been destroyed by fire in 1920.

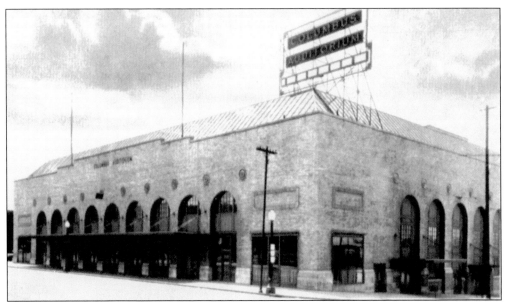

The Columbus Auditorium was constructed on the southwest corner of Front and Town Streets in 1927. It served to hold functions that could not fit on the small stage of the Memorial Hall (constructed in 1906) and events not adaptable to that venue. Among the events held in the auditorium were boxing and wrestling matches, dancing, opera, and Ohio State University basketball games. In 1946, the building was purchased by Lazarus and became the Lazarus annex. It was razed in 1992.

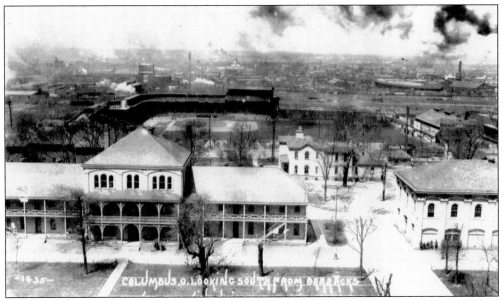

This rare photograph, looking west from the shot tower at Fort Hayes, shows a small part of Fort Hayes in the foreground but is most noted for showing Neil Park, the dark structure in the left center above the Fort Hayes buildings. Neil Park served as Columbus's baseball stadium from 1904 until 1932, but its exact orientation was not known until this photograph was discovered.

PORT COLUMBUS
COLUMBUS, OHIO

Where Plane and Train meet.

In 1929, Columbus was selected as a transfer point on the fastest coast-to-coast means of travel. Two nights by train and two days by plane could get one from New York to Los Angeles in 48 hours compared to four or five days by train alone. Passengers coming by train from New York transferred to Ford Trimotor aircraft at the new Port Columbus airport.

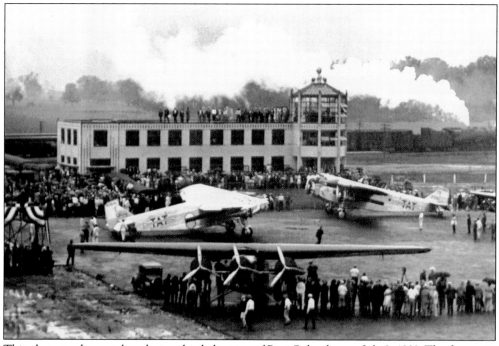

This photograph was taken during the dedication of Port Columbus on July 8, 1929. The first train to bring passengers to the station can be seen in the background. The two Ford Trimotor aircraft on which they would leave Columbus waits in front of the original terminal in the foreground.

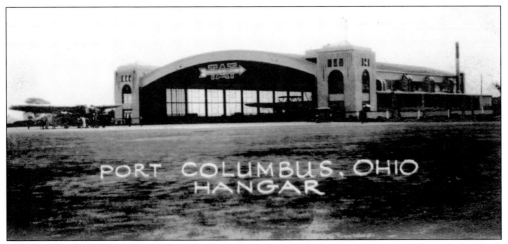

The Transcontinental Air Transport (TAT) hangar was the first hanger at Port Columbus. Constructed in 1929, it was repainted with the original TAT insignia for the 75th anniversary of the airport in 2004.

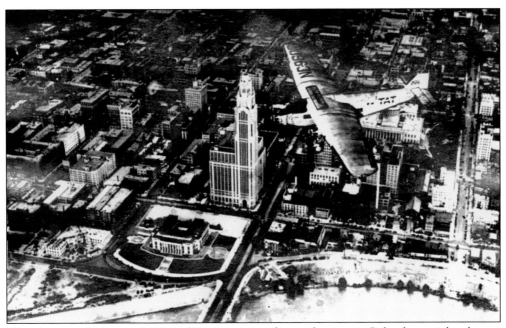

This photograph shows a TAT Ford Trimotor aircraft over downtown Columbus as it heads west from Port Columbus to its first stop in Indianapolis. The aircraft could carry 14 passengers. The coast-to-coast trip cost about $339 when service was initiated.

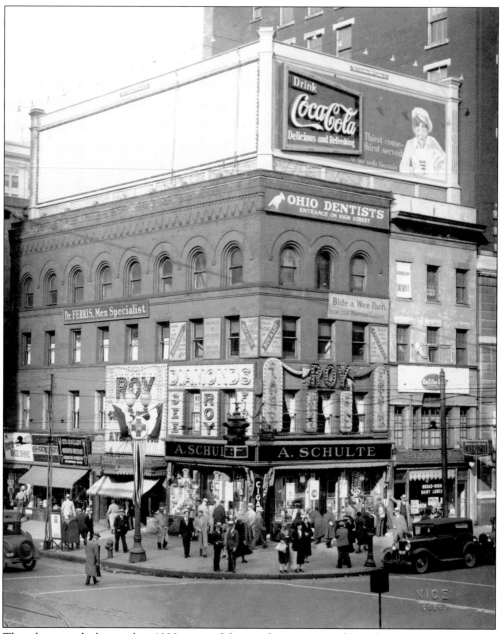

This photograph shows a late 1920s view of the northeast corner of Board and High Streets. Roy Jewelers later occupied the first-floor corner store. After looking similar to this view for about 80 years, this corner is presently undergoing renovation.

Four

1930–1939

THE DEPRESSION YEARS

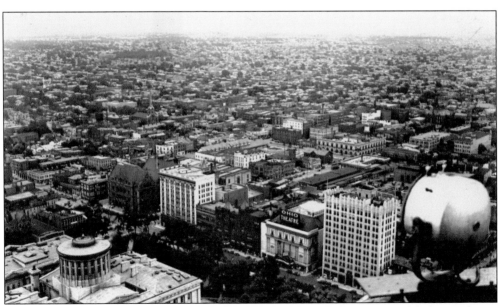

In this 1931 view of Columbus, looking southeast from the top of the AIU Citadel, the statehouse (lower left), the Ohio Theater (lower right), and the federal building (dark building above southeast corner of the statehouse) are the only major buildings that have survived. This federal building is now the home of the Bricker-Eckler law office.

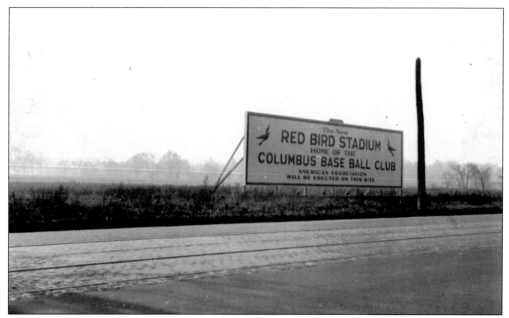

In 1931, the St. Louis Cardinals baseball team purchased the Columbus baseball club and added it to their farm system. A billboard was placed on property on West Mound Street at Glenwood Avenue in 1931 to announce that a new stadium, Red Bird Stadium, would be built for the American Association team.

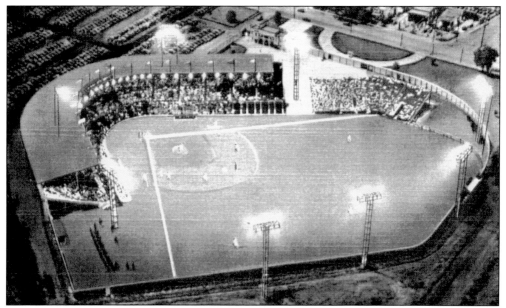

Red Bird Stadium was one of the first minor league stadiums equipped with lights. In 1955, the Red Birds became the Jets and the stadium became Jet Stadium. Since then it has been Clipper Stadium, Franklin County Stadium, and Cooper Stadium. It is owned by the county.

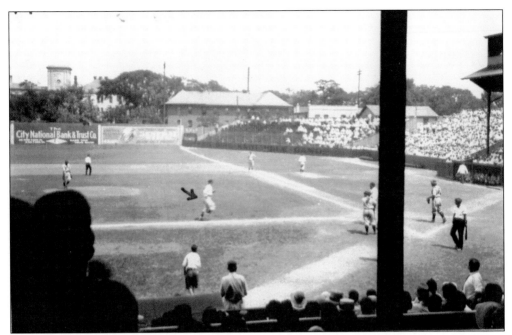

One of the last games is played in Neil Park before the baseball team moved to the new Red Bird Stadium. The arrow identifies Al Grabowski, who is scoring after hitting a home run. The Fort Hayes shot tower can be seen above the trees over the pitchers mound. The bleacher near the center of the picture carries the name "Knot Hole Gang." Youngsters could get a pass to certain games for a small charge. In the late 1940s, a season pass to Saturday afternoon games at Red Bird Stadium cost Knot Holers 50¢.

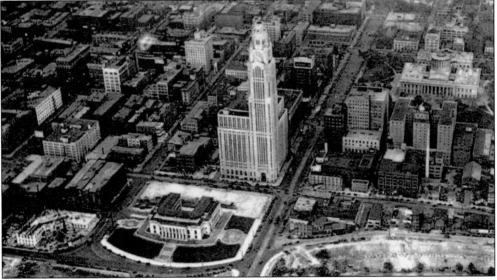

This photograph shows the new Columbus Police Station being constructed in 1931 at the northeast corner of Gay Street and Marconi Boulevard (lower left corner of photograph). It served until the police department moved to a new building in 1991. This building is now empty, waiting for funds to be available to convert it to some useful purpose. Also seen in this photograph is city hall as originally built, without the east side that was added in 1934.

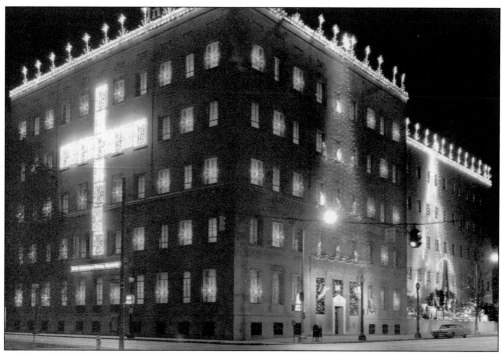

In 1931, the State Automobile Insurance Company began an annual tradition of decorating its building at Broad Street and Washington Avenue for Christmas. In later years, its display included a life-size diorama with figures illustrating the Nativity story. Local choirs perform daily during the weeks before Christmas.

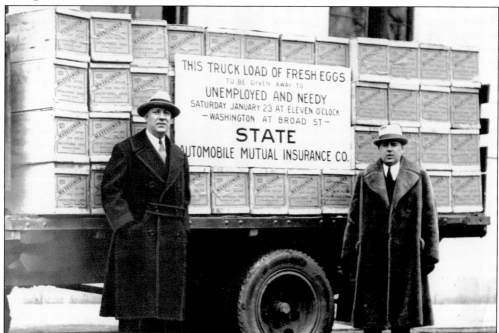

The State Automobile Insurance Company performed other community services, including distributing a truckload of eggs to unemployed and needy persons in 1932.

"THIS BEAUTIFUL SIXTY FOOT BAR IS SOLID QUARTERED SAWED OAK, HAND CARVED; FRESH CUT FLOWERS DAILY THE YEAR ROUND"

The Jai Lai restaurant opened on High Street near Goodale Street in 1933. Although highly successful in that location, it had to move in the 1950s when the Goodale leg of the freeway was constructed. It continued its success after relocating to Olentangy River Road, especially among Ohio State football fans. After the Jai Lai closed in 1996, the building became the Buckeye Hall of Fame restaurant.

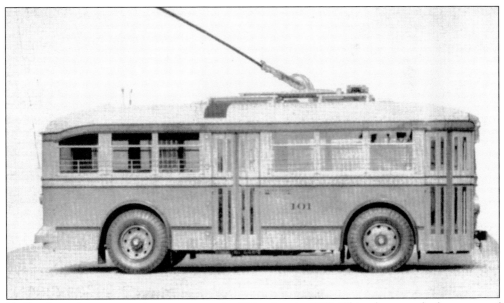

Trolley buses began to replace streetcars in Columbus in 1933. This photograph shows one of the first trolley buses used in Columbus. Converting to trolley buses meant that the streetcar/bus company no longer had to maintain tracks. Additionally, passengers could be picked up at the curb instead of the middle of the street.

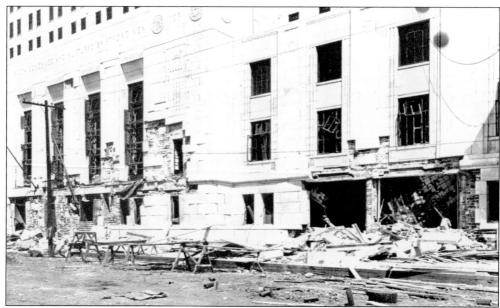

The Ohio State Departments Building on Front Street at State Street was constructed as part of the Civic Center between 1931 and 1933. When the building was nearing completion, there was an explosion that severely damaged parts of the lower floors. The explosion was attributed to gas. The building was repaired and placed in service in 1933. It has recently been refurbished and now serves as the Ohio Courts Building. The interior is decorated with many works of art representing Ohio history.

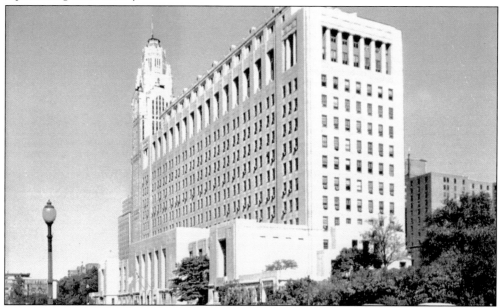

The Ohio State Departments Building joined the recently erected city hall and police station and the soon-to-be-erected federal building in creating a civic center along the east bank of the Scioto River in downtown Columbus. Directly across the river was Central High School, now COSI, and later the Veteran's Memorial. Still, Columbus has yet to determine how to make an asset of its riverfront.

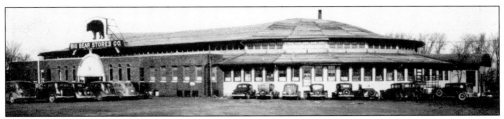

In 1934, a Big Bear supermarket opened in this former roller-skating rink on West Lane Avenue, just east of the Olentangy River. This is credited by some for being the first supermarket in the country, or at least the first in the Midwest. This Big Bear store was sold and then razed in 1985, to be replaced by an apartment building.

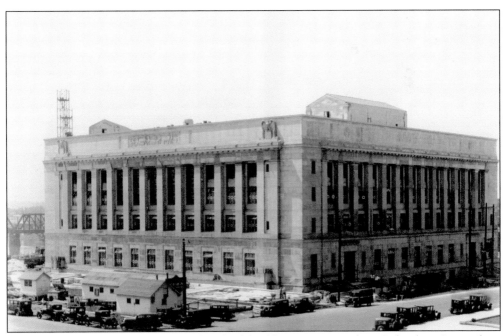

In 1934, a new main post office and federal building was erected in Columbus. Located on Marconi Boulevard, it still serves as a federal office building but not as a post office.

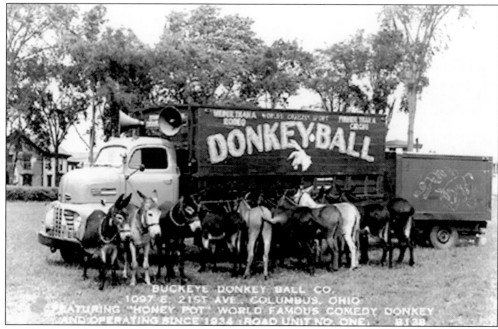

In 1934, the Buckeye Donkey Ball Company was formed to entertain by playing baseball on donkeys. This photograph shows some of the donkeys and the truck and trailer used to transport them.

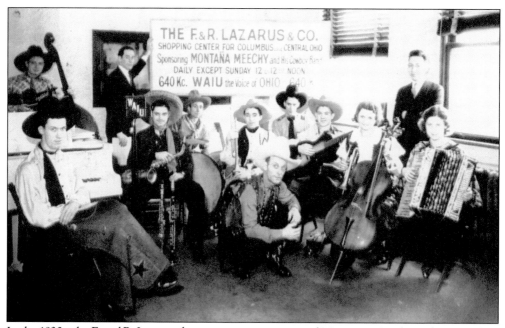

In the 1930s, the F. and R. Lazarus department store sponsored Montana Meechy and His Cowboy Band at noon six days a week on radio station WAIU. The band included drums, a trumpet, a saxophone, an accordion, and stringed instruments. Trumpets and saxophone instruments were not widely accepted in country music until about 1960.

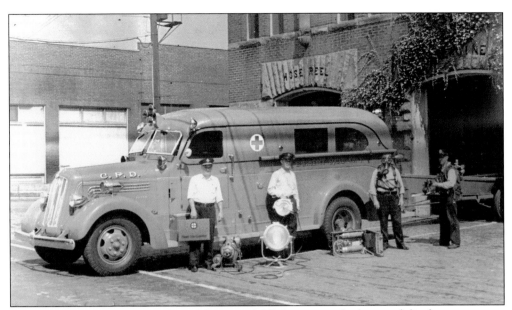

Engine House No. 6 on West Broad Street at Mill Street was the home of the first emergency squad operated by the Columbus Fire Department. This undated photograph shows Squad No. 1 at that station and is presumed to date from the mid-1930s. The vehicle was built by Seagrave, a Columbus company. As Engine House No. 6 was the closest fire station to the Scioto River, it was natural for that station to have a boat for water rescues. It can be seen behind the squad.

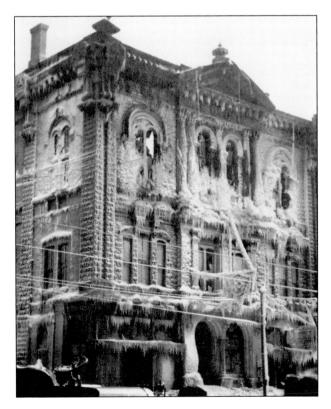

In February 1936, the Odd Fellows building at Rich and High Streets caught fire. Fighting the fire was difficult because of the 10 degrees below zero temperature, which caused ice to form on the building and on the firefighting apparatus. During the fire a wall collapsed, killing five firemen. From the perspective of the fire department, this has been the most disastrous fire in Columbus history.

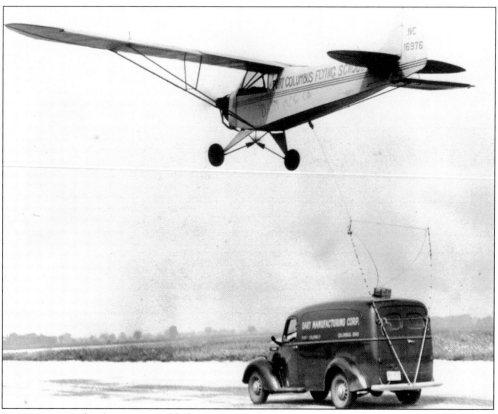

In 1938, two Columbus men established a new endurance record for light planes when they flew for 66 hours and 37 minutes without landing. They refueled by flying low over a runway at Port Columbus and retrieving cans of gasoline from a truck driving down the runway.

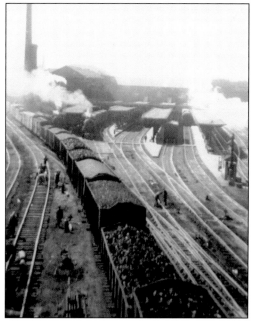

Since 1850, railroads have been an important industry to Columbus. Around 1900, the railroads employed about 9,000 persons in Columbus. While this number had decreased by the 1930s and 1940s, railroads were still a major local employer. This photograph shows railroad traffic looking west toward Union Station after 1930, when the large train shed that covered all the tracks was replaced with smaller umbrella sheds between pairs of tracks.

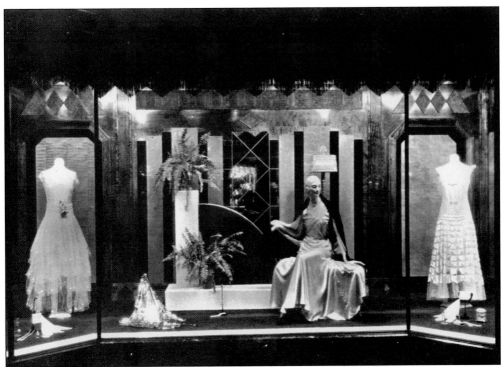

Storefront displays were an important form of advertising for department stores, attracting passersby and window shoppers in the days when downtowns were crowded and before newspaper advertising reached its present magnitude. This photograph shows a storefront display featuring women's clothing at Armbrusters department store, 150–158 North High Street, in the 1930s.

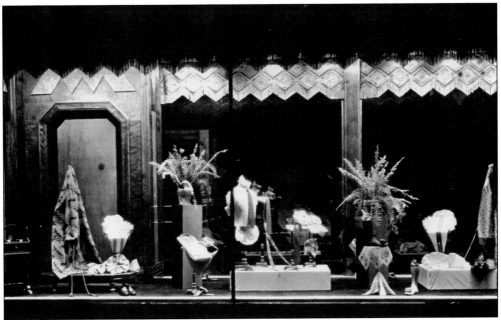

Another Armbrusters department store display featured men's clothing.

The Cambridge Arms apartments were at 926 East Broad Street in the 1930s. East Broad Street was a high-class residential area with a number of luxury (for that day) apartment buildings. Today this building is a home for senior citizens.

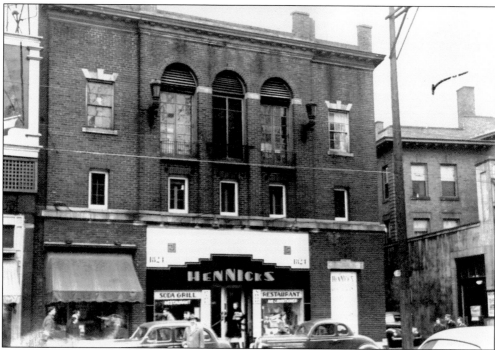

Hennicks Grill and Restaurant was at 1824 North High Street in the 1930s. Located across High Street from Ohio State University between Fourteenth and Fifteenth Avenues, it was both convenient and attractive to students.

Five

1940–1949

THE WORLD WAR II YEARS

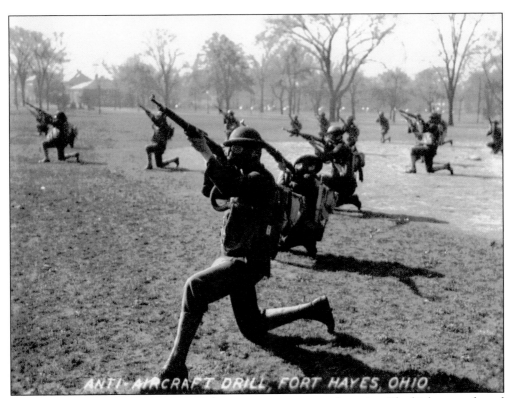

In 1940, soldiers at Fort Hayes received training in anti-aircraft tactics. The higher speeds and altitudes achieved by airplanes developed during the late 1930s and World War II essentially made this type of anti-aircraft fire obsolete.

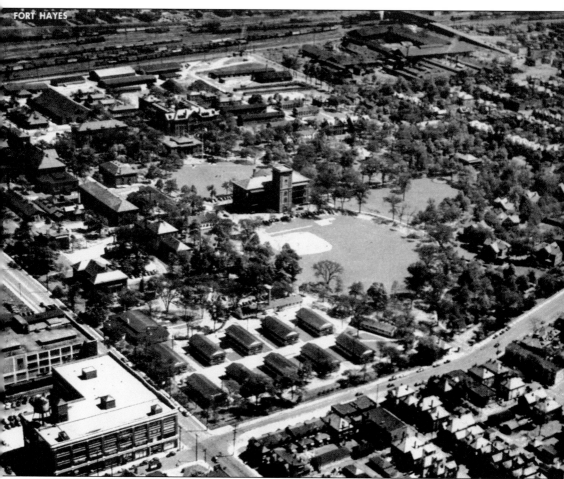

This aerial view of Fort Hayes is believed to be from the 1940s. The most prominent building is the shot tower in the center of the photograph. Contrary to the popular belief that molten lead was dropped down the tower to form shot, the tower of this building was never used for forming shot. It is one of the buildings now owned by the Columbus Board of Education and is part of their Fort Hayes Arts and Academic High School.

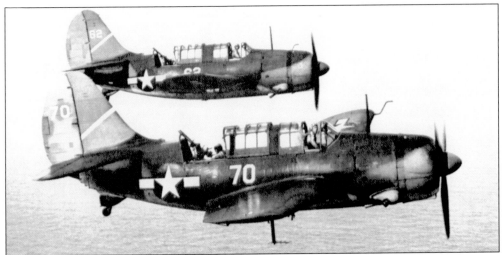

Curtis-Wright operated a government-owned aircraft manufacturing plant on East Fifth Avenue at Port Columbus during World War II. Dedicated on December 4, 1941, the plant produced 5,516 Helldiver dive-bombers during the war. Because of government-requested changes during development and manufacturing, the plane was not an initial success. However, it was developed into an effective plane and went into widespread service in late 1944.

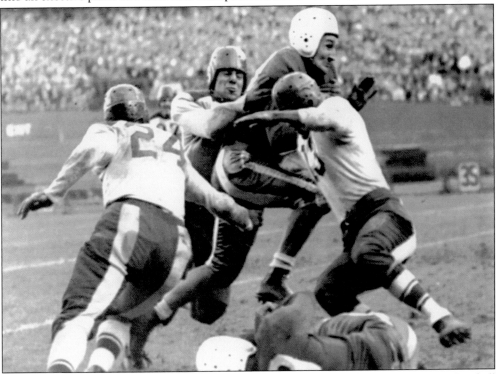

From 1939 to 1941, Columbus had a team, the Columbus Bullies or Bulls, in the American Football League (AFL). The AFL was a competitor to the National Football League until World War II drained its manpower. The Bullies won the league championship in 1940 and 1941. This photograph, although taken at an away game, shows several Bullies tackling Michigan All-American Tommy Harmon in his first professional football game in 1941.

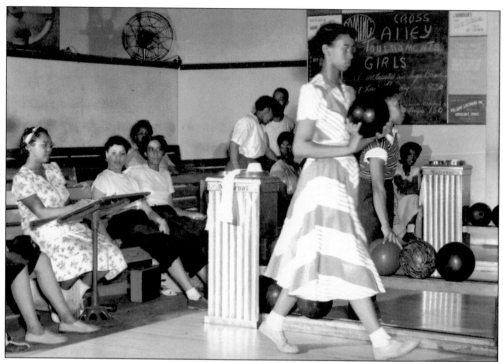

When Marion Richardson and his fellow bowlers were turned away from a downtown Columbus tournament in the early 1940s because African Americans were not permitted, he resolved to insure that black bowlers would not be denied the opportunity to bowl. He operated a bowling establishment on the second floor at 1054–1056 Mount Vernon Avenue for many years. This photograph shows bowling in this establishment at a later time.

This photograph, looking north on the east side of the 1900 block of Parsons Avenue in 1942, shows the barricades that protect a new cement sidewalk in front of Louis Mori's statuary store.

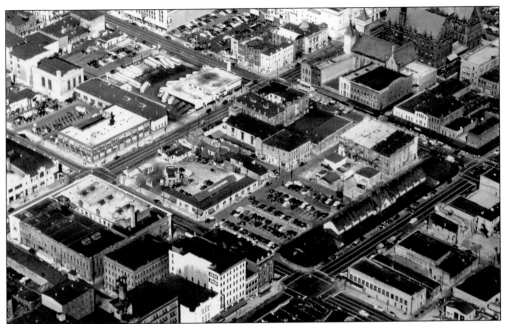

This aerial view looking northwest shows a portion of the downtown area near the Central Market in the 1940s. The long building in the lower right is the Central Market. The area directly above it is Town Street, where the wholesale produce houses were concentrated. In the upper left center is the intercity bus station. Most of the buildings shown in this view are gone, razed as part of the Market-Mohawk Urban Renewal project in 1960 or to clear the way for the City Center Mall in the 1980s.

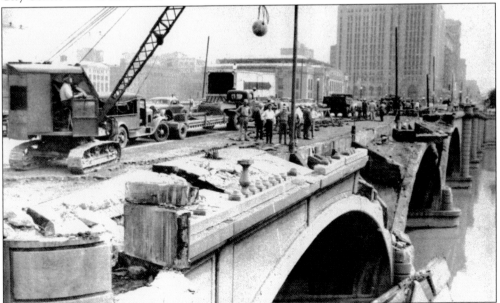

In 1947, lightning stuck the Broad Street Bridge in downtown Columbus, causing an explosion. The cause of the explosion was thought to be a pocket of natural gas that had collected within the bridge. This photograph shows the removal of damaged parts of the bridge prior to repairs. Dumping debris in the river would no longer be allowed because of water pollution laws.

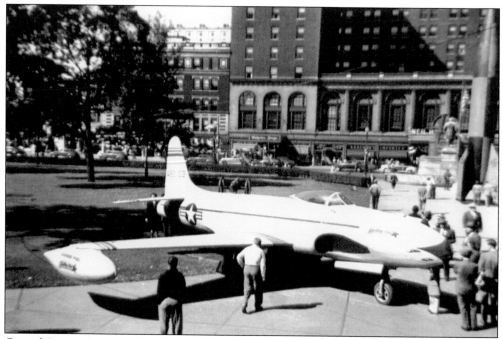

One of America's new Lockheed F-80 Shooting Star jet fighters sets in the statehouse grounds for public inspection during a 1947 aircraft display. Developed too late to see service in World War II, Shooting Stars saw action in the Korean War.

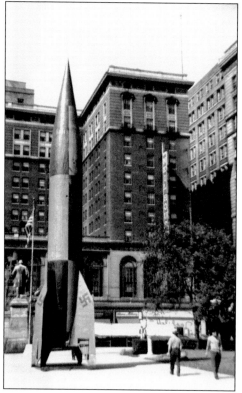

Another item on display was a captured German V-2 rocket of the type that the Germans launched against England during World War II. It is posed across High Street from the Neil House Hotel.

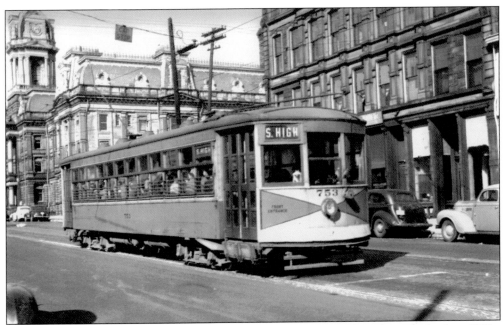

World War II slowed the replacement of streetcars with buses. Thus, through the late 1940s, streetcars remained a major means of transportation in Columbus. Here a southbound High Street car passes Fulton Street with the Franklin County Courthouse in the background.

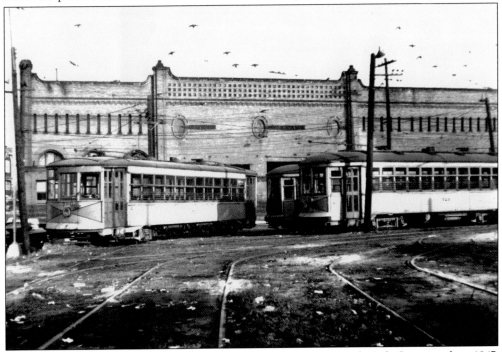

This photograph shows the streetcar barn at Arcadia Avenue and High Street in late 1947. Several streetcars are ready for service. When the streetcars were removed from service the next year, they were sold; some were used for housing while others found service as storage sheds and as chicken coops.

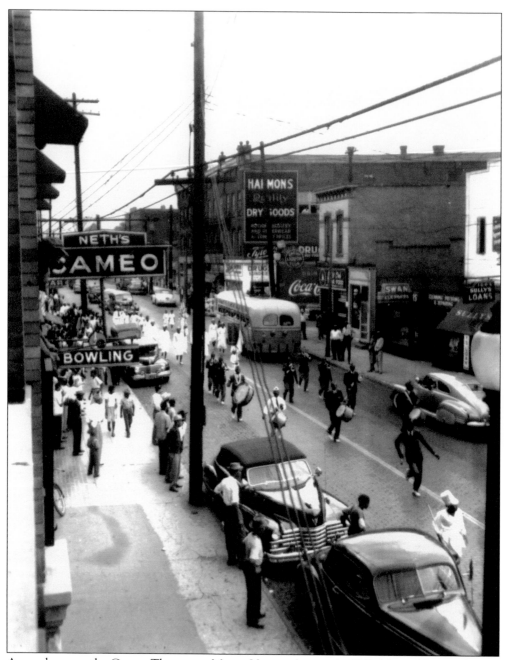

A parade passes the Cameo Theater on Mount Vernon Avenue in 1949. Mount Vernon Avenue was a vibrant business center for the African American community in east Columbus from the 1930s until it was cut off from the downtown area by the construction of a freeway in the 1960s.

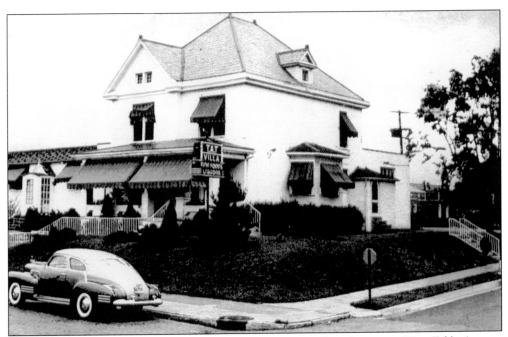

Papa and Mama Persutti opened an Italian restaurant in their home on West Fifth Avenue in the late 1920s. As their business grew, they expanded several times. This view shows the restaurant in the late 1940s. The business closed in 1981.

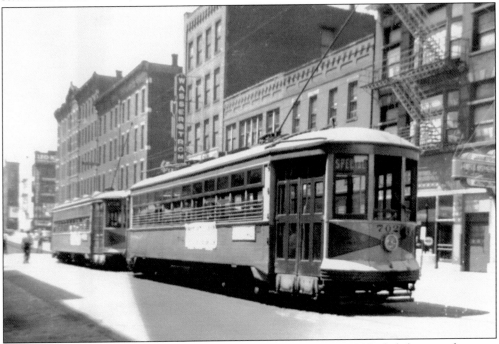

Rail fans take one last ride on Columbus streetcars on August 1, 1948, slightly more than one month before streetcar service ended in Columbus. This view looks west on Chestnut Street from Third Street. The streetcar company provided special rides to rail fans as streetcar service faded from the scene.

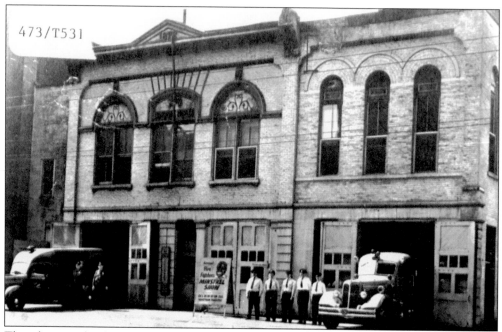

473/T531

This photograph of Engine House No. 3 was likely taken in the late 1940s. This engine house was opened in 1872 and after being enlarged, served until 1962. The annual firemen's minstrel show is advertised in the display board at the center of the driveway.

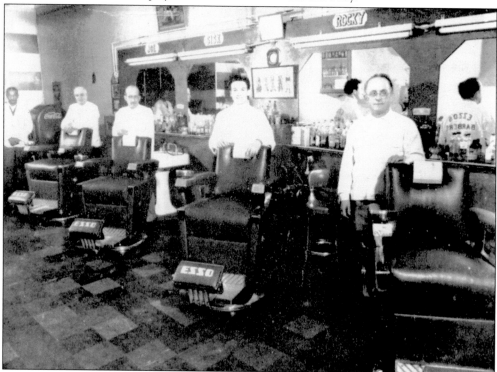

Ezzo's Barber Shop at 2820 West Broad Street offered four barbers in the 1940s. The barbers were Charles Ezzo, Rocky, Sisk, and Joe. The man to the left may have provided shoe shines.

Six

1950–1959

POST-WAR GROWTH

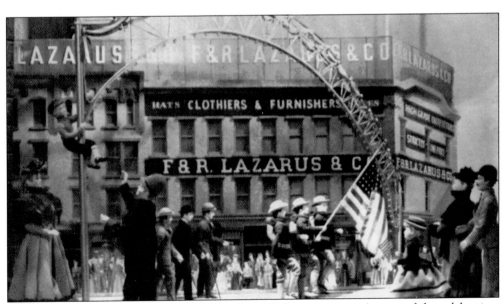

In 1951, Lazarus department store celebrated its 100th anniversary. As part of the celebration, its windows were decorated with dioramas showing scenes from Columbus history. This diorama depicts a parade honoring troops returning from the Spanish-American War; it was entitled "Johnny comes marching home."

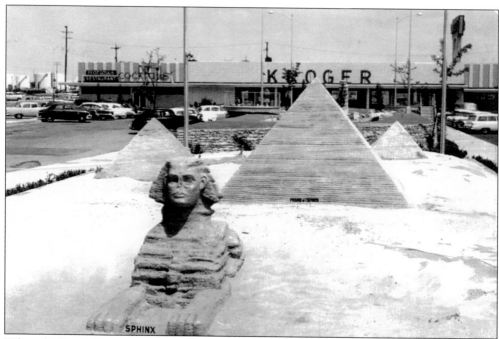

When the Great Western Shopping Center was constructed in 1953, recreations of nine wonders of the world were erected in the parking lot as attractions. The nine wonders were the sphinx and great pyramids of Egypt, the Parthenon of Athens, the Eiffel Tower, Niagara Falls, the Grand Canyon, Carlsbad Caverns, the Taj Mahal, the Leaning Tower of Pisa, and the Fountain at Trevi. This photograph shows the sphinx and pyramids.

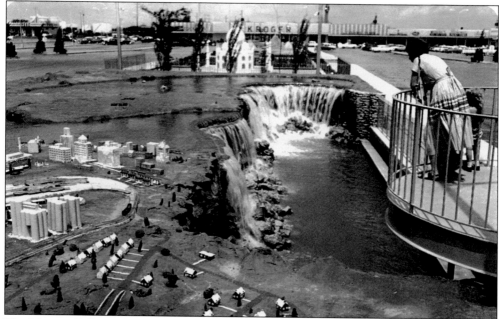

The Niagara Falls model had water running over both the American and Canadian Falls. A liberty was taken in constructing the Canadian Falls, as these falls do not impact on rocks as the photograph shows. A portion of Niagara Falls, New York, is shown in the foreground.

Over the years, as the models deteriorated, they were removed rather than being maintained. The last wonder to remain was the Eiffel Tower. It was constructed of steel and thus was more durable than the concrete models. The tower, which appears to be about 18-feet tall, is said to still reside in a backyard in the Columbus area.

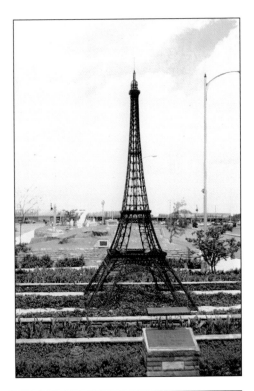

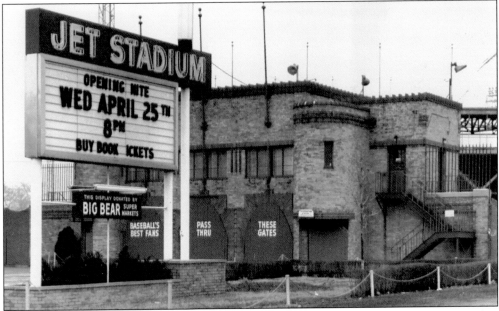

After the 1954 season, the St. Louis Cardinals moved their Red Bird team to Omaha. Columbus had to seek another franchise if the city was to continue to have minor league baseball. Columbus secured the Ottawa franchise in the International League and a working agreement with the Kansas City Athletics. The name of the ball club was changed from the Columbus Red Birds to the Columbus Jets (in recognition of the aircraft manufacturing by North American Aviation). This photograph shows the entrance to the renamed Jet Stadium.

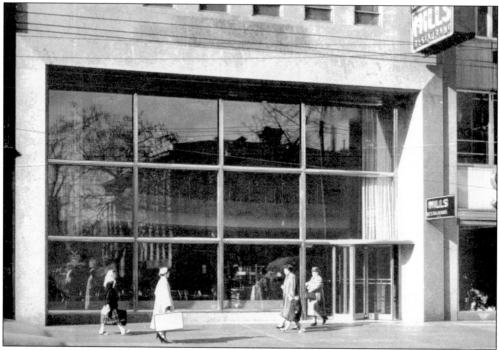

The Mills' Restaurant at 77 South High Street is shown in a 1953 photograph. This Mills' Restaurant, which had opened in 1916, was a long-time favorite in downtown Columbus.

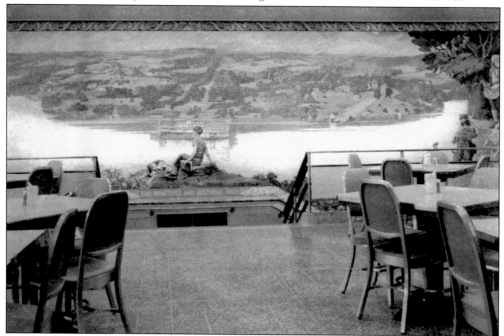

In 1952, a 50-by-20-foot mural was installed on the wall adjacent to the stairway leading to the second floor of Mills' Restaurant. The mural was entitled "The Beautiful and Historic Ohio" and depicted an Ohio River scene complete with a riverboat and a boy seated on a rock viewing the scene.

In 1951, the firemen of Engine House No. 11 at 1000 East Main Street use their hook and ladder truck as a scaffold during the repainting of their station. The net for catching persons jumping to escape flames is visible on the right side of the vehicle. Such nets are not used anymore.

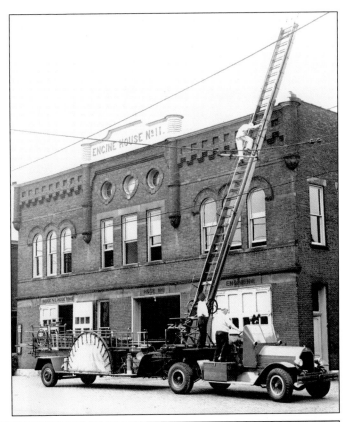

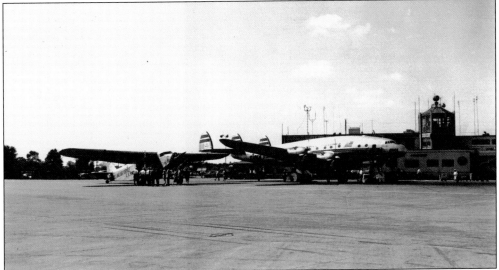

In 1954, Columbus celebrated the 25th anniversary of its airport, Port Columbus. One activity was the bringing to Columbus of a Ford Trimotor airplane of the type that flew from the airport in 1929. This photograph shows the Trimotor parked along side of a Lockheed Constellation, a first-class airliner of the day. The original airport terminal, which was still in use, is in the background. Although terminal activities were moved to a new location in 1958, this older terminal has been restored and is used as an office building.

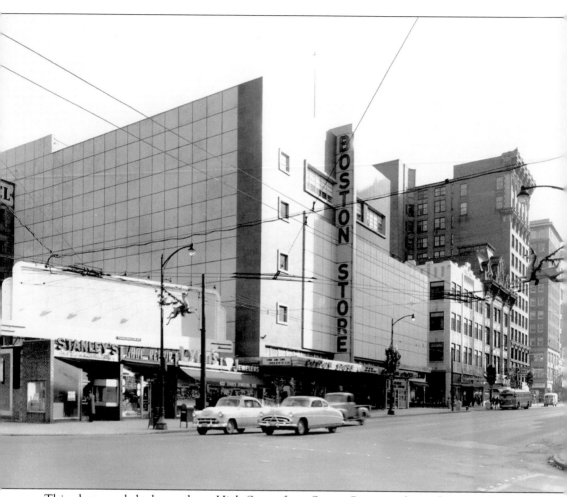

This photograph looks south on High Street from Spring Street in the mid-1950s; of note are the downtown Boston Store, which closed in 1963, and the Christmas decorations on the light poles. Of the buildings pictured, the only two buildings that remain on the east side of High Street between Spring and Long Streets are the Boston Store building (since modified) and the Atlas Building on the northeast corner of Long and High Streets.

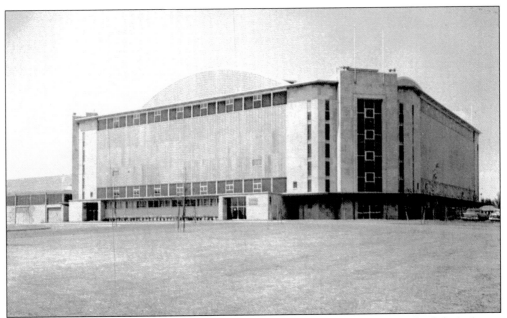

The Ohio State University opened a new arena in 1955 on Lane Avenue. St. John's Arena permitted the university's basketball team to return to playing games on campus. Previously, the Buckeyes were playing at the Ohio State Fairground coliseum. St. John's sat 13,425 and was the home of the basketball Buckeyes until the Schottenstein Center opened in 1998.

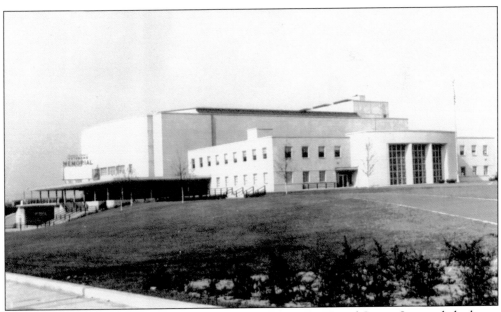

A new Veteran's Memorial Hall was opened in 1955 on West Broad Street. It provided a larger and more versatile facility for staging shows than the Memorial Hall, which had opened in 1906. Although the Veteran's Memorial has faced increased competition since the opening of Columbus's convention center, it still has events most weekends.

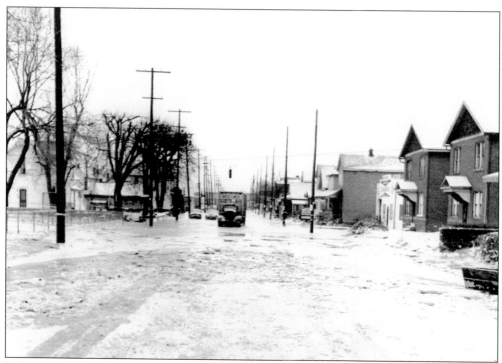

In January 1959, Columbus experienced its first widespread flooding since 1913. Once again, a levee along the Scioto River gave way, and the Franklinton area was flooded. The extent of the flooding was much less than in 1913, and no lives were lost.

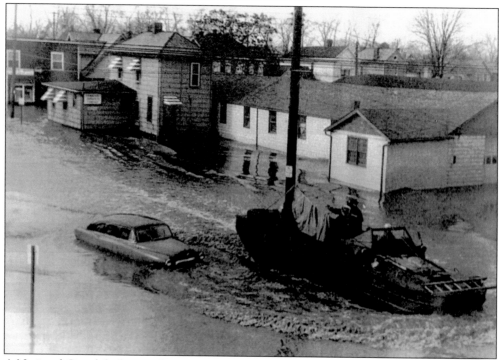

A National Guard duck is used to rescue people stranded by the 1959 flood.

Seven

1960–1970

Columbus Bursts its Shell

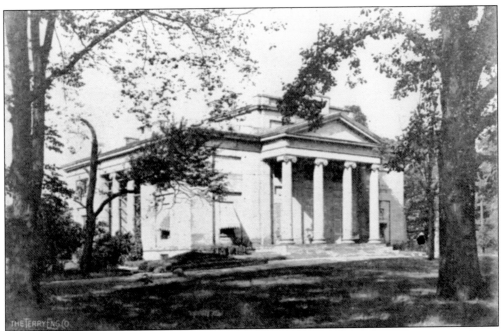

In 1961, the Alfred Kelley mansion at 282 East Broad Street was dismantled to clear space for the Christopher Inn. In 1837, Kelley had put the partially completed mansion, constructed from 1836 to 1838, up as collateral when the state of Ohio was about to default on bonds financing construction of Ohio's canals. During disassembly, the stones were marked and stored so that the mansion could be reconstructed at another site. The reassembly never happened and at last report, the stones were being stored near Akron.

In 1960, a movement began to restore the area immediately south of downtown Columbus. This area was historically the home of much of the German population of Columbus. However, it mostly contained small houses and was not considered a desirable residential area. Additionally, it had become rundown and was considered for slum clearance.

Through the efforts of a few persons, the area was revived and now thrives as German Village. It is the largest privately conducted restoration project in the country and is considered a desirable residential area, primarily for being close to downtown. The annual Haus and Garten Tour attracts thousands.

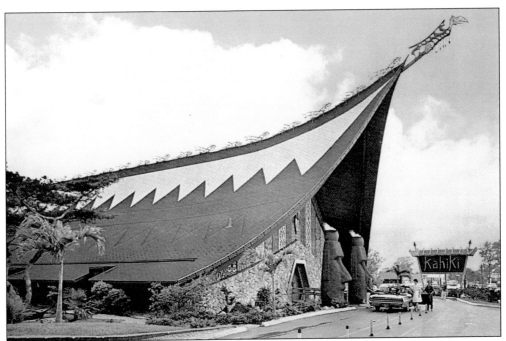

In 1961, a Polynesian restaurant, the Kahiki, opened at 3583 East Broad Street. It was an immediate success and was considered a premier dining spot for many years. Attractions included a waterfall, Polynesian huts, and great food. The Kahiki was sold in 2000 and razed to clear the land for a pharmacy.

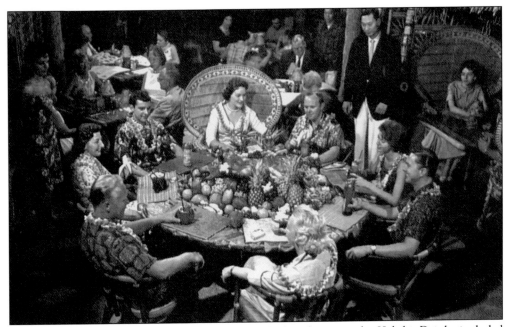

This photograph shows patrons enjoying a drink before dinner at the Kahiki. Drinks included "The Headhunter," "The Suffering Bastard," "The Erupting Volcano" (complete with dry ice eruption), "The Zombie," and its signature "Mystery Drink."

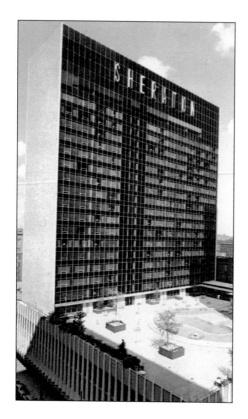

In 1962, Columbus saw the construction of its first building over 12 stories tall since 1927. The Columbus Plaza was erected on the southeast corner of Gay and Third Streets. The hotel building has not had a history of success, and the property has changed hands several times. Known as the Columbus Sheraton when this photograph was taken, it also operated as the Sheraton Columbus Plaza, the Adams Mark Hotel, and presently the Columbus Renaissance Hotel.

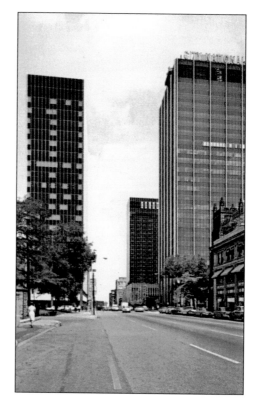

The building of the Columbus Plaza seemed to unleash a wave of construction of tall buildings in downtown Columbus. This 1960s photograph looks north on Third Street from State Street and shows the Key Bank Building on the left, the Columbus Sheraton in the center, and the City National Bank (later Bank One Building and now Columbus Center) on the right. Columbus has seen the construction of numerous other skyscrapers during the past four decades.

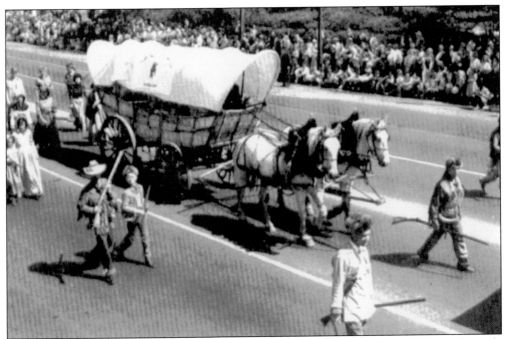

In 1962, Columbus celebrated its sesquicentennial. The major event was a sesquicentennial parade in May. One of the parade elements that drew the most attention was this Conestoga wagon entered by the Bill Moose Muzzle Loading Gun Club of Columbus. Bill Moose (1837–1937) claimed to be the last surviving Wyandot Indian in Ohio.

The Northland Mall was opened in 1964 on Morse Road. When it was first opened, Northland was an open-air mall; however, the walkway between the two rows of stores was later covered over to create an enclosed mall. Northland was closed in 2002, when the new Easton Town Center and Polaris Fashion Place took away its business.

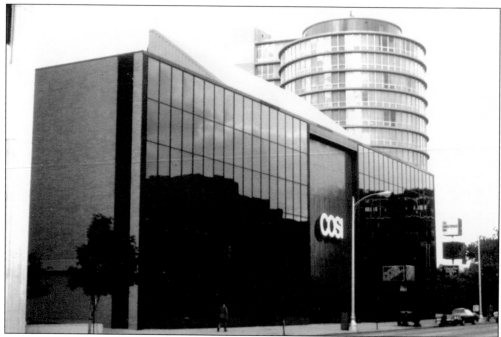

After the Veteran's Memorial opened, there was less need for Memorial Hall as an entertainment facility. In 1964, the Memorial Hall was converted to a Center of Science and Industry, or COSI. This was accompanied by adding a glass front to the building and displaying several vehicles in the enclosed area. Among the vehicles displayed was a horse-drawn milk wagon. After COSI moved to its current home in 1999, the glass front was removed.

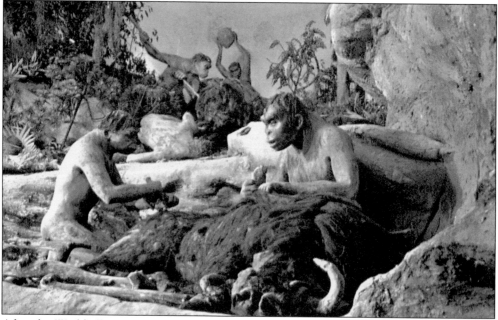

After the World's Fair in New York closed in 1965, the Triumph of Man exhibit was acquired and was installed at COSI. Consisting of life-size dioramas, it portrayed important steps in the development of man, from the dawn of civilization to space travel.

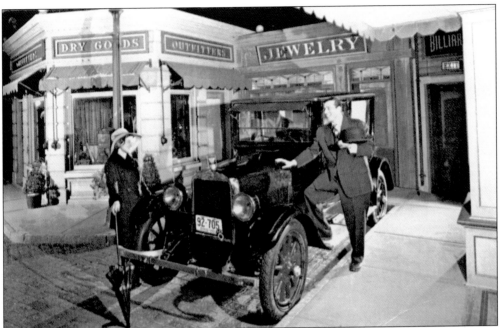

Another attraction at COSI was the Street of Yesteryear. It featured shops of the 1860–1880 period and a talking 1923 Oakland automobile that told some of the history of automobile production in Columbus.

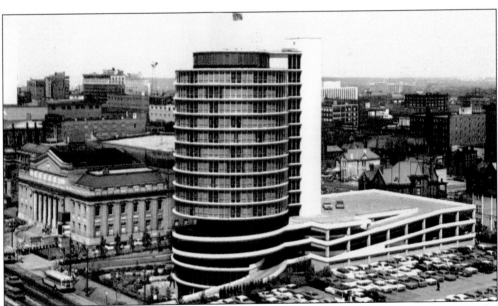

One of the more unusual buildings constructed in Columbus during the 1960s was the Christopher Inn, opened in 1963. As seen in this photograph, it was located on East Broad Street, immediately east of Memorial Hall. The unique feature of the Christopher Inn was its round design. The Christopher Inn operated until 1988, when it was razed.

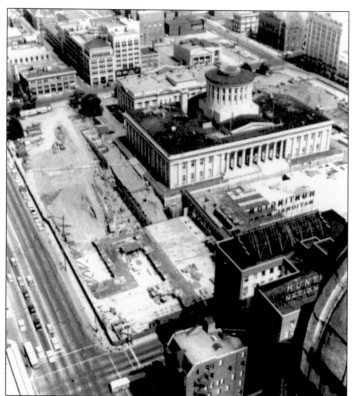

In 1964, an underground parking facility was constructed beneath the statehouse yard. This view, from the LeVeque Tower, shows the statehouse yard during the construction of the garage.

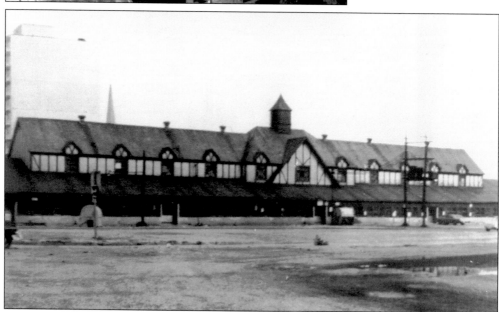

In 1966, as part of the Market-Mohawk Urban Renewal project, the old central market house (built between 1850 and 1851) was razed. This photograph was taken shortly before the razing. The razing of this building disappointed many residents who were accustomed to going to the Central Market on Tuesdays, Thursdays, and/or Saturdays, the days the market was open and the surrounding streets were lined with stalls offering fresh fruits and vegetables.

Schmidt's was a longtime Columbus butcher having operated in Columbus since 1886. In the 1960s, city laws made it increasing difficult (if not impossible) to operate a slaughterhouse within the city. Thus, in 1968, Schmidt's converted their German Village butchering facilities into a restaurant. In spite of a major fire in 1983, they have developed a successful business and are famous for their Bahama Mama sausages and giant cream puffs.

Near its last days, Columbus Union Station was deserted most of the time in the late 1960s and early 1970s. Columbus was only served by one passenger train during this period—a daily Chesapeake and Ohio train from Ashland, Kentucky, to Detroit and back.

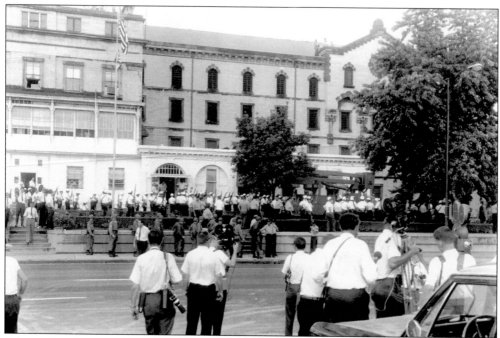

After a disturbance at the Ohio Penitentiary in June 1968 that caused $1 million in damage, a full-blown riot broke out in August. Inmates held nine hostages for two days. This photograph shows Columbus police and National Guard troops assembled in front of the penitentiary cellblock seized by the inmates.

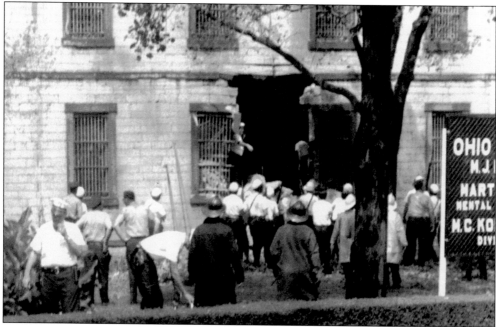

The riot ended when a hole was blown in the front wall of the penitentiary, and safety forces rushed through. The hostages were freed unharmed. One prisoner died in the blast, and four others died from gunshots fired by safety forces.

Eight

THE OHIO PENITENTIARY

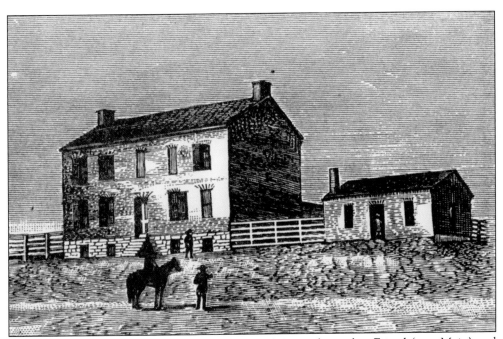

The first Ohio Penitentiary was completed in 1815. It was located at Friend (now Main) and Scioto Streets, approximately where the Cultural Arts Center is presently located. This drawing is said to depict the penitentiary after an 1813 addition. It soon became evident that this penitentiary was too small, and a location was sought for a new prison. Persons wishing to use prisoner labor in their factories offered a plot of land in northwest Columbus, on what became the northeast corner of Spring Street and Dennison (now Neil) Avenue.

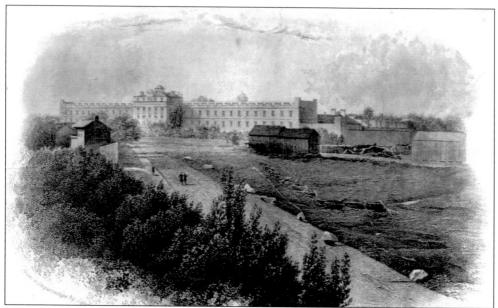

The Ohio Penitentiary was built between 1833 and 1834 and received its first prisoners in the fall of 1834. This 1850 drawing of the Ohio Penitentiary illustrates what it looked like in its early days. The only cellblock at that time was the cellblock that faced south and was parallel to what later was Spring Street. The eastern and western sections of the cellblock were referred to as East Hall and West Hall, respectively. When the penitentiary was razed in 1997, this was the one structure that preservationists were most interested in saving.

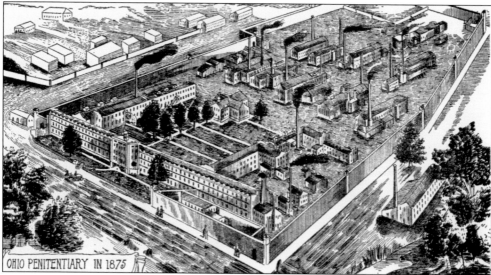

This drawing of the Ohio Penitentiary in 1875 was made by a convict who was serving a 15-year sentence for counterfeiting. Between its opening and 1875, the penitentiary had been enlarged to the north, the original cellblock had been extended east, and the New Hall cellblock had been constructed parallel to Dennison Avenue (now Neil Avenue). The penitentiary boundaries remained the same between the time of this drawing and when the penitentiary was closed in 1984. However, to meet changing needs and because some buildings were damaged during several riots and fires in the 1960s, the buildings within the walls changed from time to time.

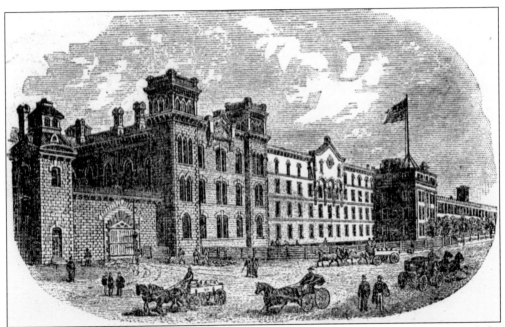

This drawing shows the front of the Ohio Penitentiary in 1883. The appearance of the penitentiary building did not change significantly during its final 100 years. However, the yard in front of the penitentiary changed from well-maintained landscaping and grass to a parking lot during its later years.

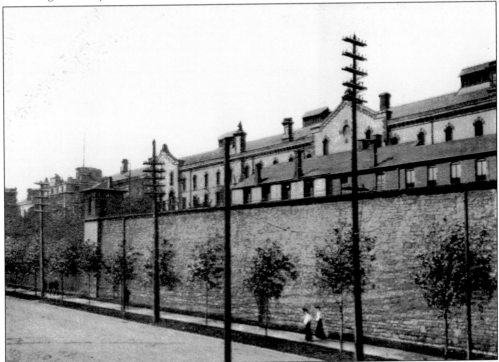

The wall along the west side of the penitentiary can be seen in this view. The New Hall cellblock can be seen over the top of the wall.

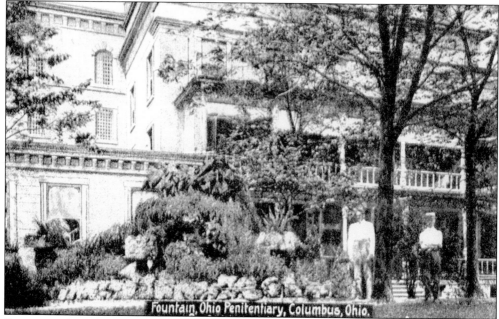

Fountain, Ohio Penitentiary, Columbus, Ohio.

From its earliest days through at least the 1930s, the entrance of the Ohio Penitentiary was landscaped. During the first decade of the 20th century, the landscaping included a fountain, as shown in this view. Well-behaved prisoners (trustees) were permitted outside the penitentiary walls to perform chores, such as maintaining the prison landscape. At least as late as the 1960s, Ohio's Governor Rhoades had a trustee driver who was a convicted murder.

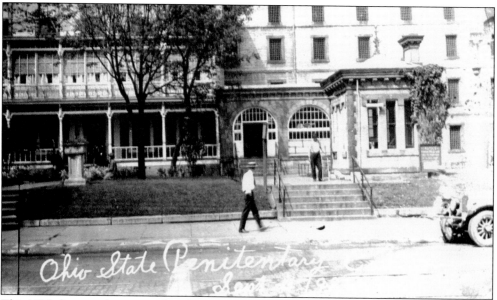

Ohio State Penitentiary

This 1925 photograph suggests that the entrance had been simplified by that time. Although the entrance was still landscaped, the fountain was gone, and the entrance appears more sterile.

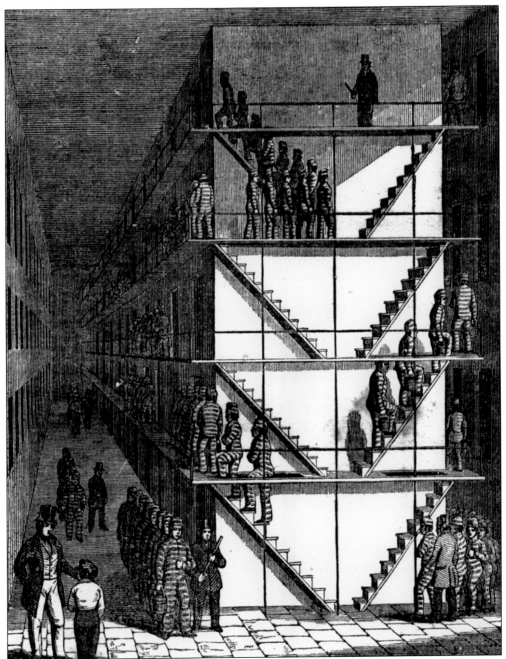

This 1891 drawing of prisoners returning to their cells shows two things of interest. First, it shows the structure of the cellblocks. The buildings consisted of outer structures that were essentially large barns and cellblocks that were freestanding structures within these barns. Thus, the prisoners had no access to the windows in the outer structure. Secondly, this drawing illustrates the discipline exercised at the time, with the prisoners marching in single file and in step.

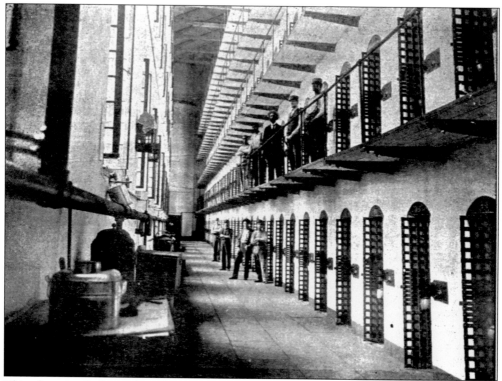

This photograph shows the cellblock as originally constructed; the masonry walls and close-meshed doors did not permit much ventilation during hot weather.

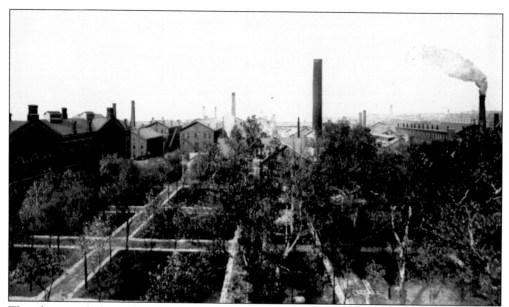

This photograph shows the Ohio Penitentiary yard about 1910. The yard appears well maintained with sidewalks, grass, and trees. Some of the penitentiary's industrial buildings can be seen over the tops of the trees.

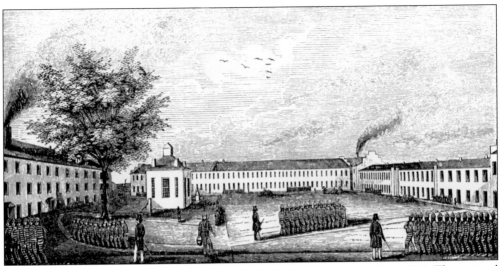

This drawing shows the inside of the Ohio Penitentiary looking south about 1840. The original caption states that the buildings to the right and left (and an unseen building to the rear) are industrial buildings and the building in the center, or south side, is the cellblock. This drawing again illustrates the rigidity with which prisoners were moved about the grounds—in single file and in lockstep.

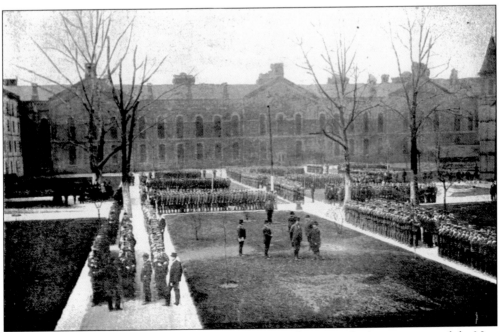

This photograph shows a similar scene from about 1910. This view is looking west toward the New Hall. The caption on this picture indicates that the prisoners were about to march to dinner.

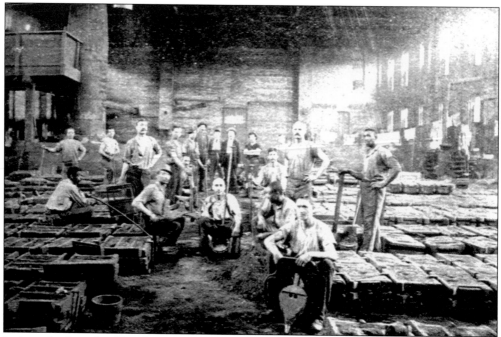

In its early days, the Ohio Penitentiary furnished labor for industries surrounding it, with some prisoners working under guard at company plants. Other prisoners could not be trusted outside the penitentiary walls and so industrial facilities were built within the penitentiary yard. This 1910-era photograph shows prisoners working in the foundry. Gradually the unions gained strength and had legislation passed to limit prisoner work, claiming unfair competition for work.

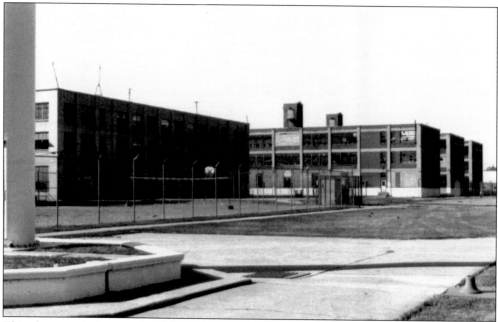

This photograph shows some of the industrial plants within the Ohio Penitentiary's walls at the time of its closing in 1984. At that time, the prison yard was barren.

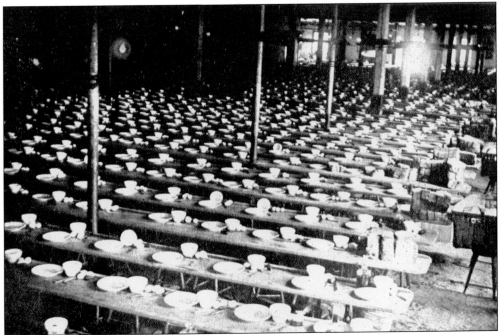

Disciplinary rules at the Ohio Penitentiary varied from time to time, sometimes being more strict and sometimes more lenient. This view shows tables in the dining hall set for the prisoner's meal during a time when strict discipline was enforced. All the prisoners were required to sit facing the same direction, and the prisoners were not allowed to speak.

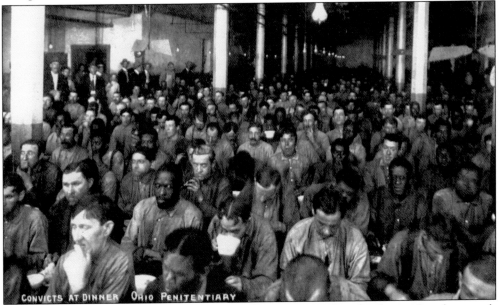

CONVICTS AT DINNER OHIO PENITENTIARY

This view shows the prisoners at dinner. Considering prisoners' civil rights, such a photograph as this (showing prisoners' faces) probably would not be permitted today. Prisoners' rights were less important in early days, and tours of the penitentiary were given into the 1950s. State Fair week always brought a demand for tours, as many persons from out-of-town were in Columbus, and the penitentiary was on many of their lists of sights to see.

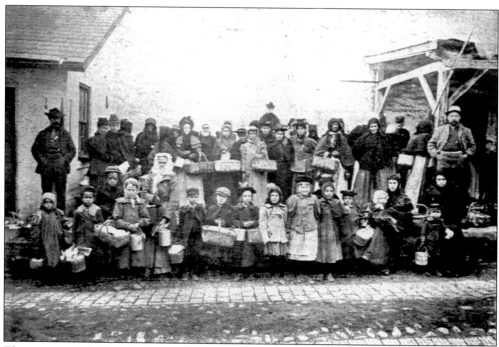

The caption on this 1899 photograph reads, "Noon scenes at the south-east prison gate—children and feeble poor waiting with baskets for the scraps left by the prisoners at dinner."

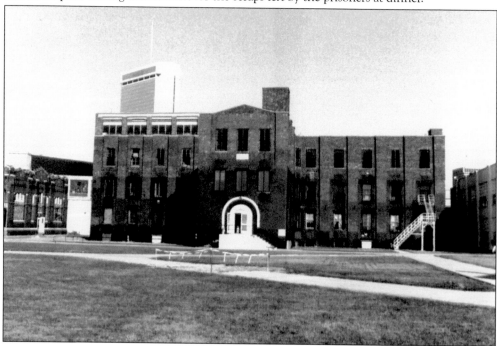

With a population of several thousand, sickness and injury were natural occurrences at the Ohio Penitentiary. The St. James hospital provided for prisoners' medical needs. In serious cases, the prisoner might be taken to a local hospital under guard. This 1984 photograph shows the St. James hospital.

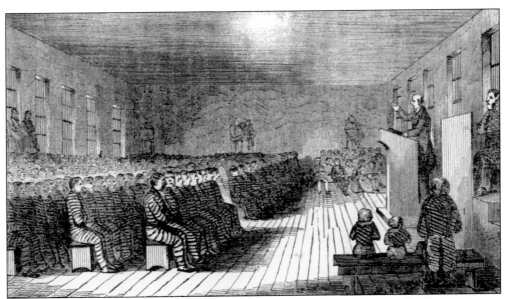

This drawing shows prisoners at chapel services at the Ohio Penitentiary in the late 1800s.

The chapel at the time of the closing of the Ohio Penitentiary is shown in this photograph. An older chapel had been destroyed in fires and riots and was replaced with this simple concrete-block structure.

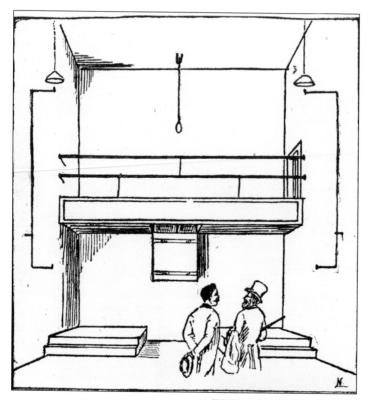

In 1885, the state legislature decreed that all executions in Ohio would henceforth be conducted at the Ohio Penitentiary. Previously, executions were conducted in the county in which the crime was committed. However, the local executions, done at the time by hanging, sometimes became public spectacles. This drawing shows the newly installed gallows at the Ohio Penitentiary. The gallows was on the second tier of cells with a trapdoor being opened to drop the prisoner.

The electric chair was installed at the Ohio Penitentiary in 1896 as a more humane means of conducting executions. If not done precisely, hangings sometimes did not produce death for 8 to 25 minutes. Following a visit by the warden to the penitentiary at Albany, New York, to examine their electric chair, an electric chair was procured and installed at the Ohio Penitentiary. It was used 315 times. When first installed, the electric chair was placed immediately below the trapdoor of the gallows, as can be seen in this picture.

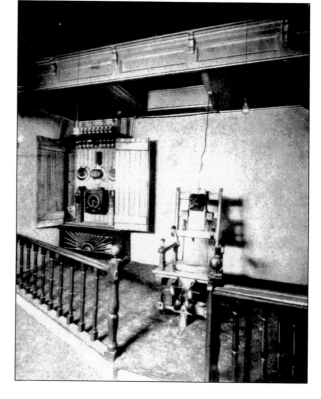

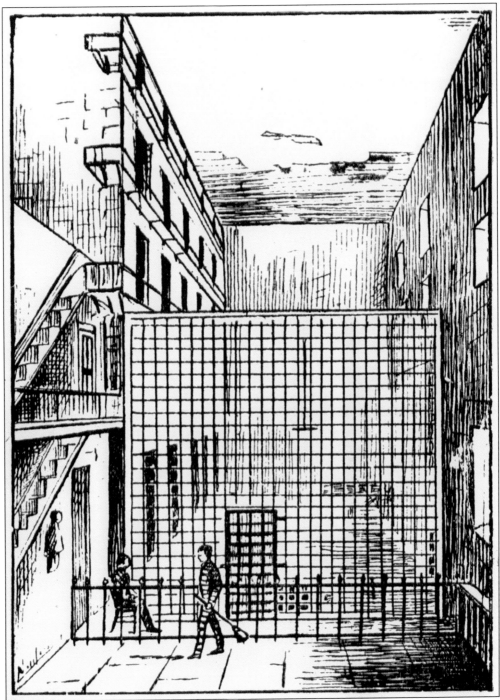

When the state mandated executions be done at the Ohio Penitentiary in 1885, it was determined that prisoners awaiting execution should be separated from the general prison population. Thus, the five cells on the south side of the east end of the original penitentiary cellblock were separated from the rest of the cells by a screen. The screened-off cells were referred to as "the cage," and condemned prisoners were confined in cells within the cage.

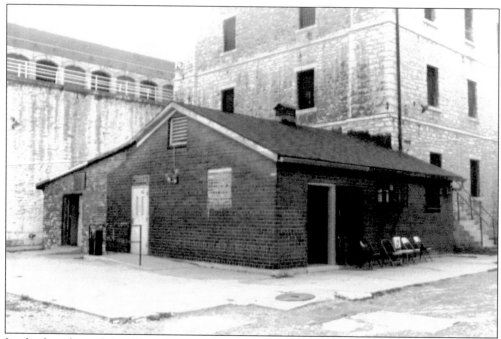

In the last days of the Ohio Penitentiary, the electric chair was located in this small brick building on the east side of East Hall. In 1972, it was moved to a new prison in Lucasville and has since been donated to the Ohio Historical Society.

From its opening until the 1930s, the warden of the Ohio Penitentiary and his family lived at the penitentiary. An apartment unit was located in the administrative area of the penitentiary. This 1898 photograph shows a part of the warden's living quarters.

One notable person imprisoned at the Ohio Penitentiary was William Sidney Porter, possibly better known by his pen name of O. Henry. Convicted of embezzlement from a bank, he was a federal prisoner who was housed at the Ohio Penitentiary from 1898 to 1901 under contract with the federal government. During his stay at the penitentiary, he worked in the pharmacy of the prison hospital. He had begun writing his short stories around 1887 and continued writing during his incarceration in Columbus.

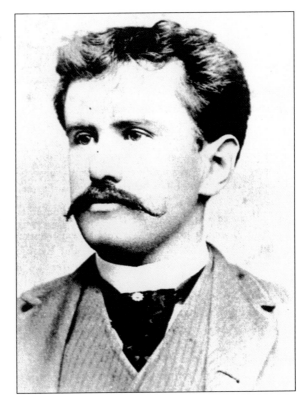

Another local famous prisoner was Doctor Snook. A professor at Ohio State University, he had an eye for the ladies and established an affair with a female student and part-time university employee. When she became pregnant and threatened to reveal their relationship, she was found murdered. Snook was convicted of murdering her in a trial that was scandalous for the explicit sexual details revealed. He was executed in 1930.

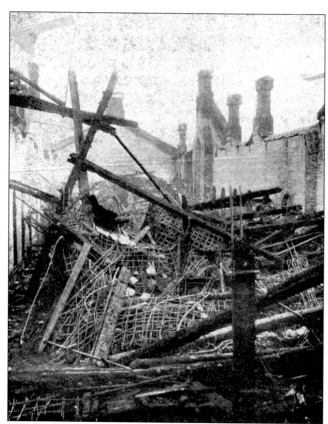

Another 1930 event at the Ohio Penitentiary was the Easter Monday fire that killed 322 prisoners. At the time, the roof of the West Hall was being replaced and oil-soaked lumber was being used for forms for pouring concrete. Supposedly, some prisoners who were working on the project planned an escape by placing a candle on a block of wood floating in a pail of kerosene. They figured that the candle would burn down and start a fire while they were at dinner and that they might escape in the confusion. Their timing was off, and the prisoners were back in their cells when the fire started.

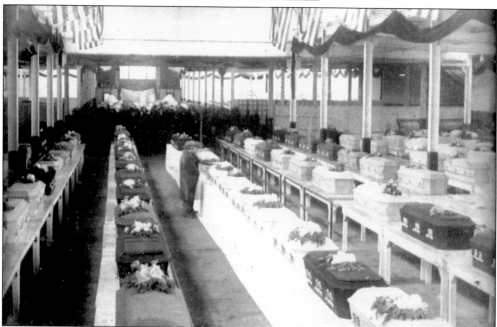

Bodies of the prisoners were taken to the Ohio State Fairgrounds for identification and to await being claimed by relatives.

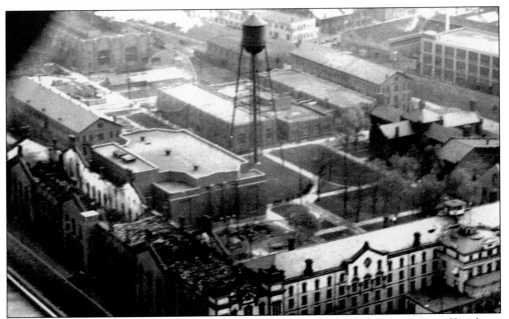

This aerial view shows the area of the 1930 fire. New Hall is on the left, and its roof has been burned away. All of the prisoners who died were in this cell block. When the seriousness of the fire became apparent, guards began letting prisoners out of the cells, but they started at the bottom. Most deaths occurred on the upper levels where the smoke was the thickest.

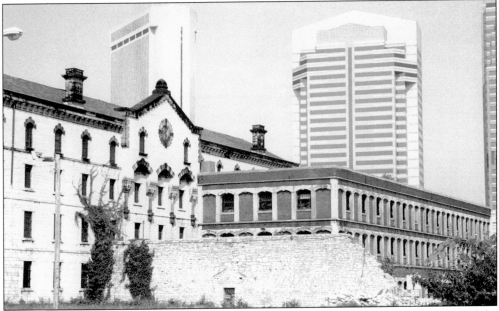

The Ohio Penitentiary was closed in 1984, but the facility remained. In 1994, a section of the penitentiary wall collapsed, falling on some parked cars. Authorities were concerned about future liability and so had the entire prison wall removed. This photograph shows where a portion of the prison wall along Spring Street has been removed. Souvenir samples of the prison wall were collected by persons interested in the penitentiary; some souvenir stones were marked with plaques noting that the stone had been part of the prison wall.

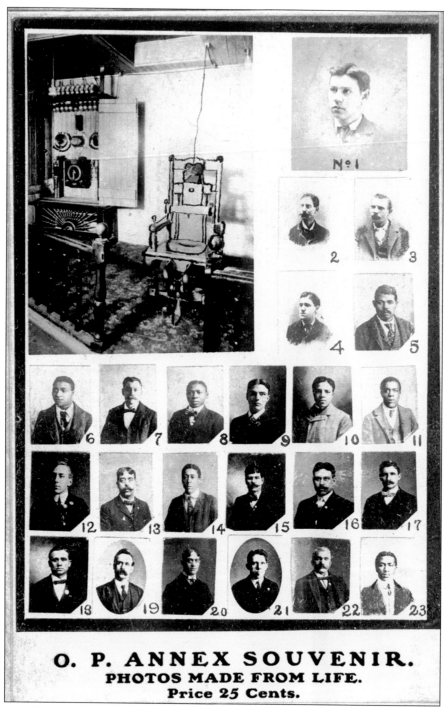

O. P. ANNEX SOUVENIR.
PHOTOS MADE FROM LIFE.
Price 25 Cents.

At least in the early years, the last stop on the penitentiary tour was at the souvenir shop. One of the souvenirs one could buy was a composite photograph of the electric chair and portraits of each person executed in it. On the back of the photograph was information regarding each person's name, date of execution, and crime for which they were executed. The sample shown here has 23 persons on it; other samples have fewer or more, depending on when it was produced.

Nine

OHIO STATE UNIVERSITY

From its beginning, the president of Ohio State University lived in an existing house at High Street and Fifteenth Avenue. The house was built for Joseph Strickler around 1856 and is referred to as the Rickly house (after its builder). It served as the university president's house until 1925. From 1873 until 1895, the presidents paid a $35 monthly rent for use of the house. After that, the university provided it at no cost.

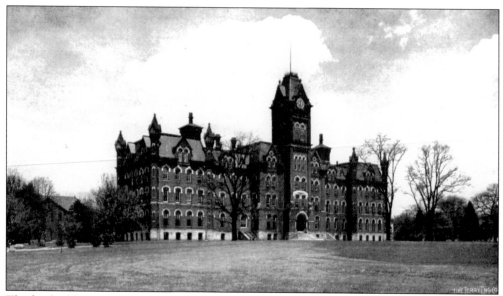

The first building constructed for the Ohio Agricultural and Mechanical College was the original University Hall. It had not been completed when classes opened in September 1873. Thus, in the beginning, this building served for classes and to house students, four professors, and workers striving to complete the building. One story tells of the student's noise keeping workers awake late and the workers retaliating by rolling cannon balls on the floor above the student sleeping quarters during early morning hours. After a tussle, they came to terms and coexisted peacefully. University Hall was razed in 1971 and replaced with a building of similar design.

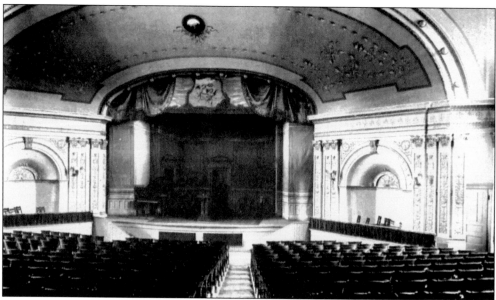

The auditorium in University Hall also served as a lecture hall and as the university's first chapel.

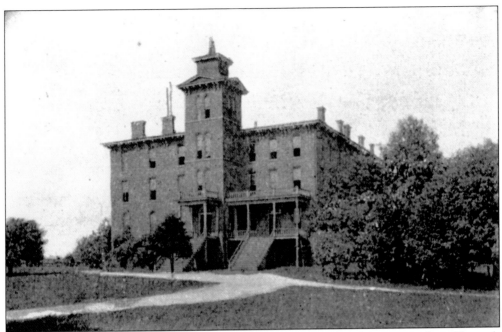

North Dorm was built in 1874; it was located on the west side of Neil Avenue at about Eleventh Avenue. Also known as the Hotel, the Boarding House, or the Big Dorm, it provided housing for 65 students and a family who operated the building. It obtained water from a well and was heated by steam from a central boiler house. It was used until 1908, when it was razed.

The South Dorm also was built in 1874; it was located on the west side of Neil Avenue at Tenth Avenue. The South Dorm or Small Dorm provided housing for 20 students; students living there cooked their own meals and obtained water from the well at the North Dorm. In 1914, the South Dorm was converted into the Homeopathic Hospital, the university's first medical building.

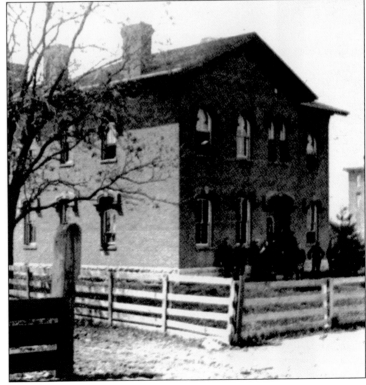

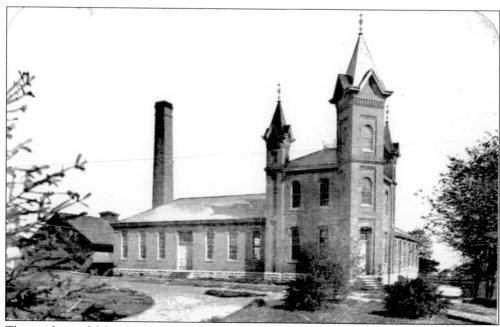

The mechanical laboratory was constructed in 1879 for the engineering department because of its need for special laboratories. Both it and the electrical laboratory building were located immediately behind (north of) University Hall. Later the mechanical laboratory became the alumni house.

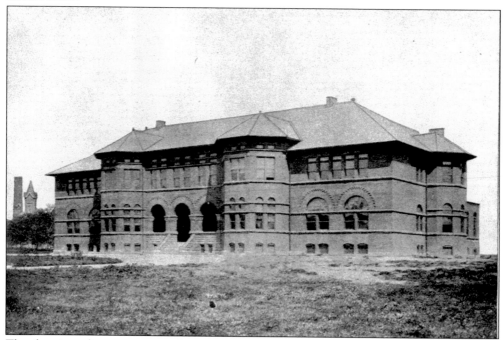

The chemistry department moved into its own building in 1882; it was located on the site later occupied by Brown Hall. It was destroyed by fire in 1889, and a replacement building met a similar fate in 1904. The chemistry department then occupied the building that became Derby Hall until the 1920s.

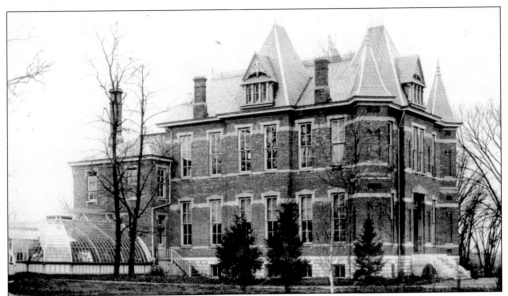

Botanical Hall, or Horticultural Hall, was erected in 1883 to serve the botany and horticulture department; it was located where the faculty club now stands.

An electrical laboratory was constructed in 1889 for the electrical engineering department but was also used for instruction in agricultural engineering and, after 1910, by the English department. It was destroyed by fire in 1914.

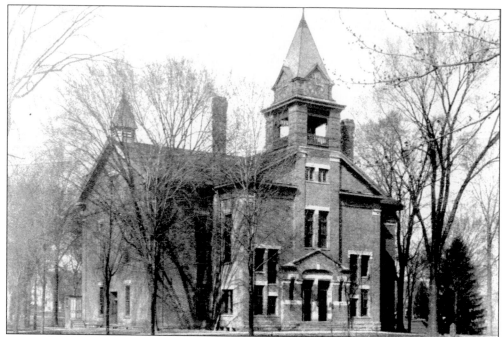

Sometime before 1891, a chapel building must have been erected on the campus, for a picture of it appeared in a publication that year. In 1881, the university trustees adopted a policy of compulsory attendance at chapel (whether in University Hall or the chapel building is not known). The university's second president, Walter Q. Scott, failed to enforce this directive, leading to his dismissal after only two years as president.

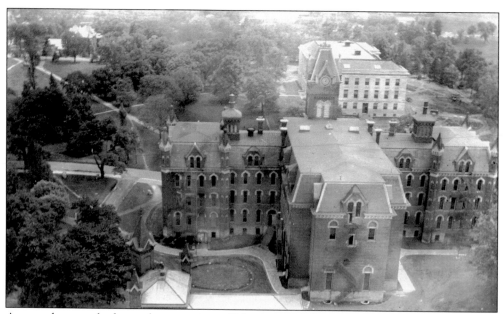

A rare photograph shows the rear view of University Hall; it must have been taken from a balloon or airplane, as there was no structure that would have afforded this view. The library is seen beyond University Hall.

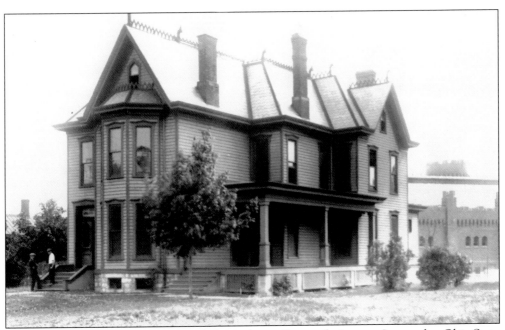

This house sat on the west side of High Street facing Sixteenth Avenue. It served as Ohio State University's athletic house from 1913 to 1931 and as the music department's annex from 1931 to 1949. The armory can be seen to the right of the house.

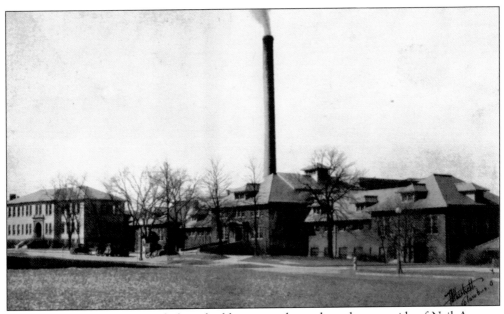

The veterinary laboratory and clinic buildings were located on the west side of Neil Avenue, which at the time ran through the campus. The stack for the university power plant is seen behind the clinic buildings in this photograph from about 1920.

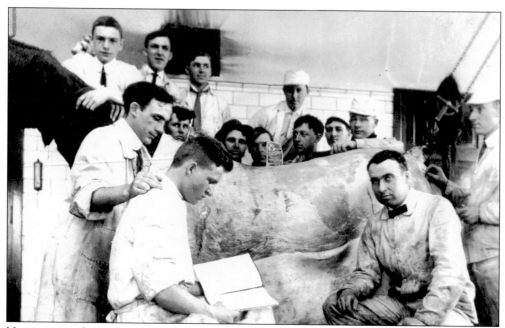
Veterinary students are seen dissecting a horse in this photograph from about 1915.

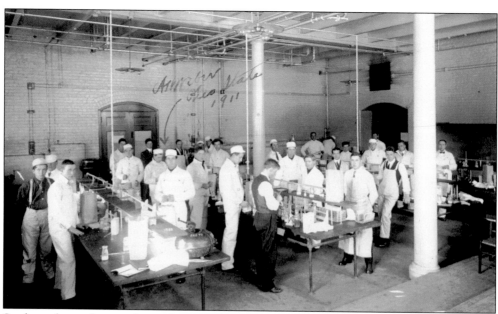
Students learned to evaluate dairy products in the dairy laboratory at Ohio State. This photograph dates from about 1914.

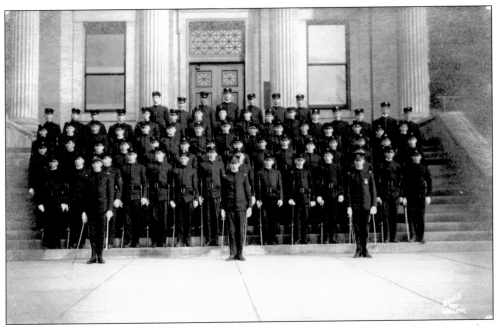

As a land grant university, from its inception all male students of Ohio State were required to participate in Reserve Officers Training Corp (ROTC). This photograph shows Company B posed in front of Page Hall about 1912.

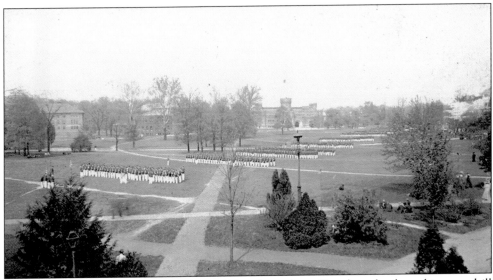

Inspection of cadets on the oval in June 1910 is shown here. Based on the date, this mass drill was probably the final cadet activity for the school year.

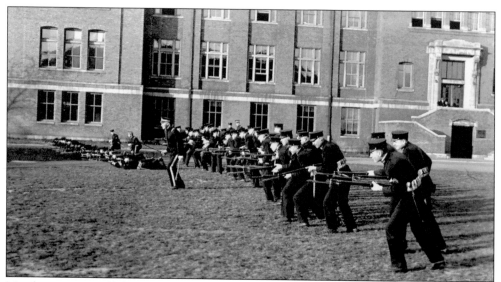

Marching was not all the ROTC students practiced. This photograph shows the 2nd Regiment, Company A drilling with rifles and bayonets in front of Lord Hall in 1915.

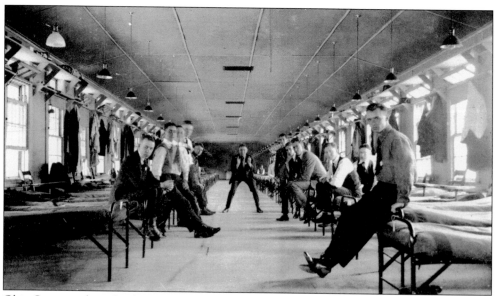

Ohio State conducted military training during World War I. This photograph shows the inside of the barracks in November 1918.

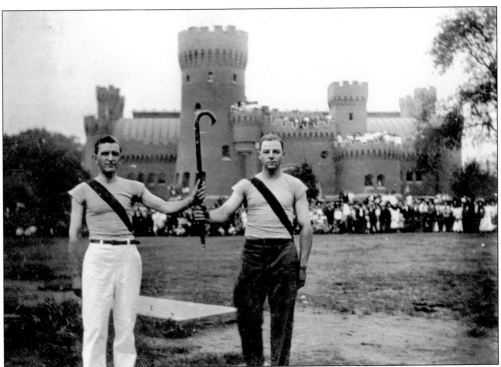

This photograph of two students holding a cane suggests that their team was the winner in the annual cane rush, a contest between freshman and sophomores. The team that could hang the cane on the goalpost of the other side won the battle. The cane rush was an annual event from at least 1906 to 1914.

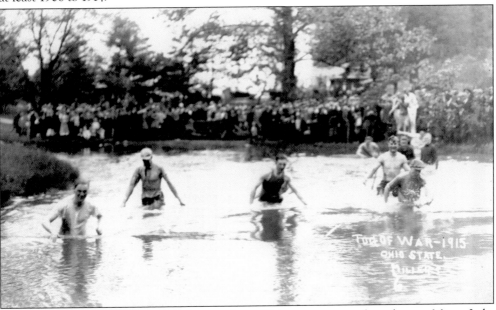

Another annual student event was the tug-of-war. This event was conducted across Mirror Lake with the losers getting pulled into the pond. This 1915 photograph shows the losing side in that year's battle.

DISCOVER THOUSANDS OF LOCAL HISTORY BOOKS FEATURING MILLIONS OF VINTAGE IMAGES

Arcadia Publishing, the leading local history publisher in the United States, is committed to making history accessible and meaningful through publishing books that celebrate and preserve the heritage of America's people and places.

Find more books like this at
www.arcadiapublishing.com

Search for your hometown history, your old stomping grounds, and even your favorite sports team.